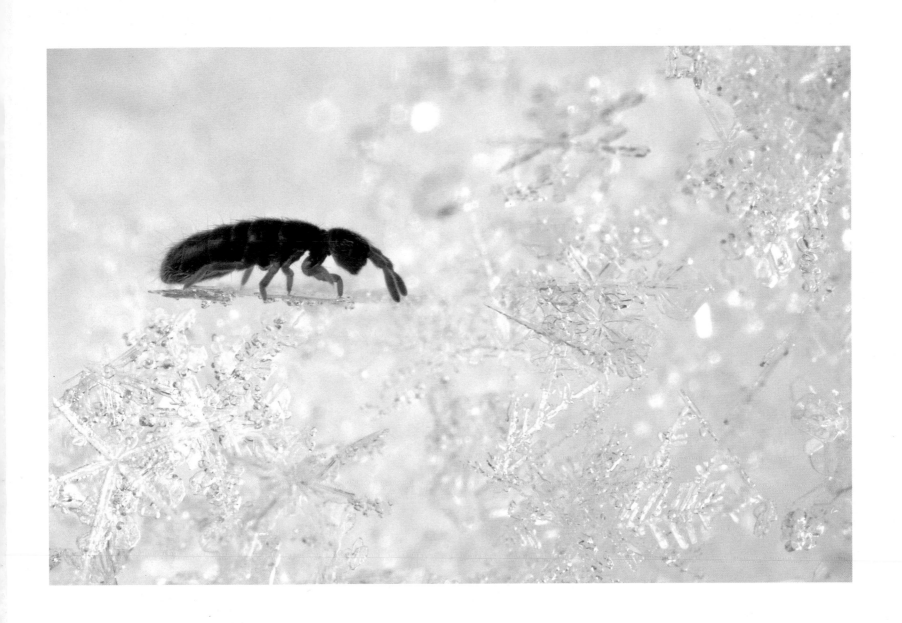

Wildlife Photographer of the Year Portfolio 19

Wildlife
Photographer
of the Year
Portfolio 19

BOOKS

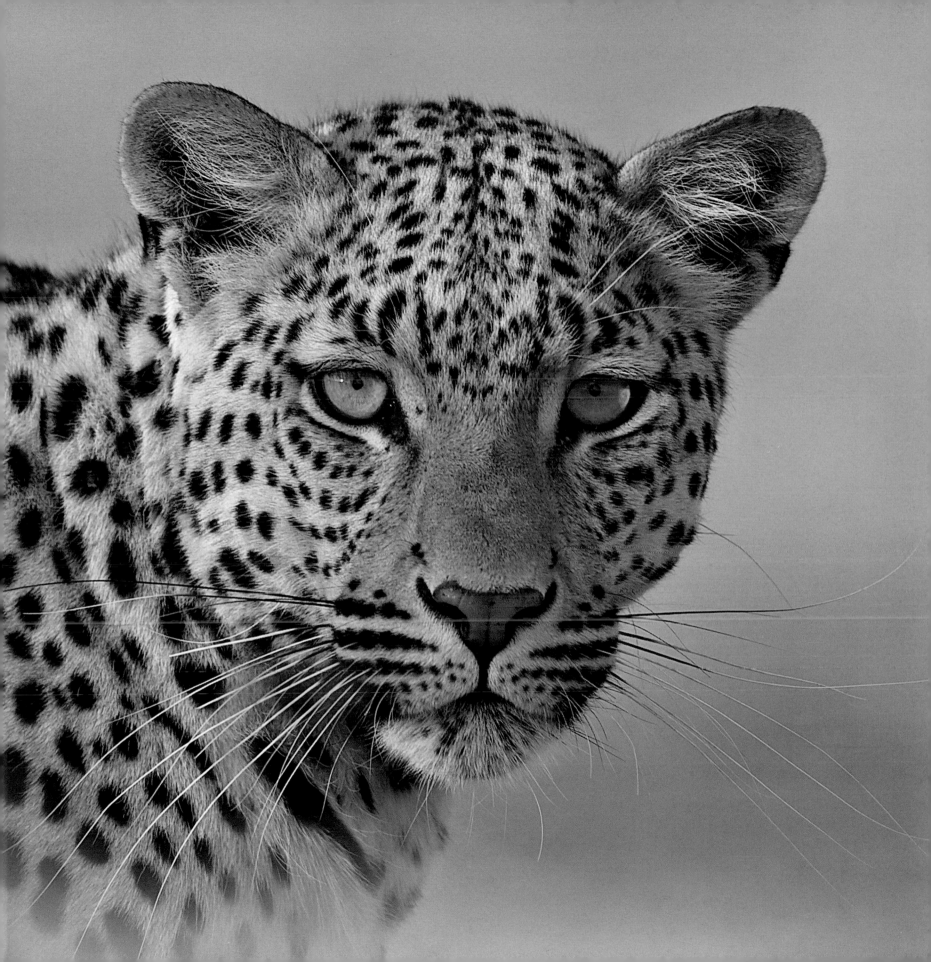

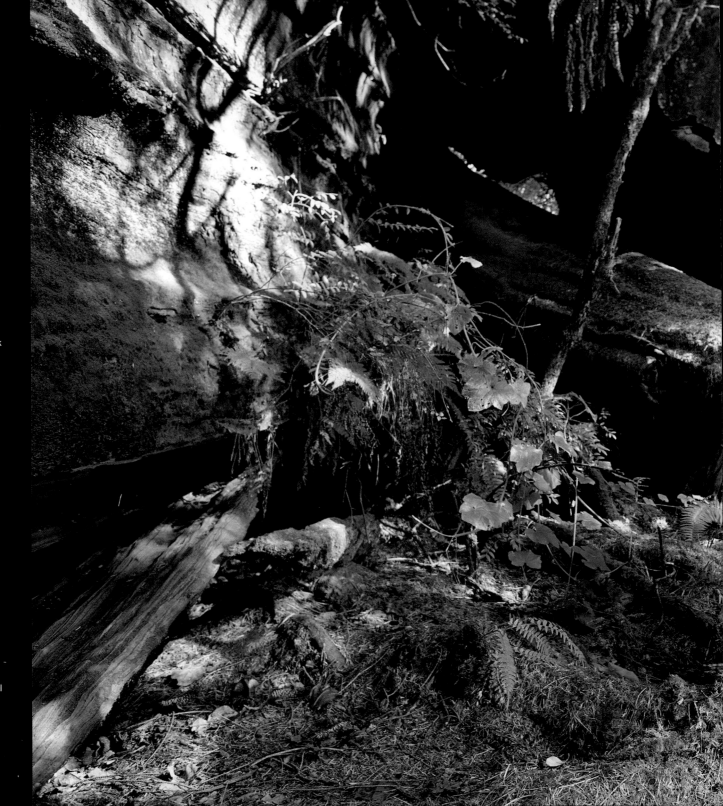

Published in 2009 by BBC Books,
an imprint of Ebury Publishing.
A Random House Group Company

10 9 8 7 6 5 4 3 2 1

The Random House Group Limited
Reg. No. 954009
Addresses for companies within
the Random House Group can be
found at www.randomhouse.co.uk

A CIP catalogue record for this book
is available from the British Library

ISBN 978 1 846 07760 9

Commissioning Editors
Muna Reyal and
Shirley Patton
Editor
Rosamund Kidman Cox
Designer Bobby Birchall,
Bobby&Co Design
Caption writers
Rachel Ashton and
Tamsin Constable
Production David Brimble
Competition Editor
Gemma Webster

Colour origination by
Dot Gradations, Wickford, England

Printed and bound in Italy by
Printer Trento SrL

The Random House Group Limited
supports The Forest Stewardship
Council (FSC), the leading international
forest certification organisation.
All our titles printed on FSC certified
paper carry the FSC logo. Our paper
procurement policy can be found at
www.rbooks.co.uk/environment

Mixed Sources
Product group from well-managed
forests and other controlled sources
www.fsc.org Cert no. CQ-COC-000012
© 1996 Forest Stewardship Council
FSC

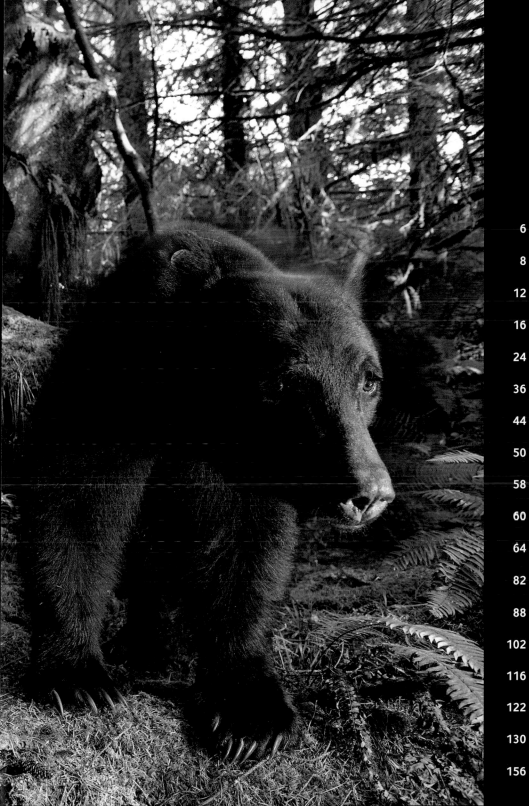

Contents

6 Foreword

8 The competition

12 Wildlife Photographer of the Year Award

16 Creative Visions of Nature

24 Behaviour – Mammals

36 Behaviour – Birds

44 Behaviour – All Other Animals

50 Nature in Black and White

58 Urban and Garden Wildlife

60 In Praise of Plants

64 Animal Portraits

82 Wild Places

88 Animals in Their Environment

102 The Underwater World

116 One Earth Award

122 Gerald Durrell Award for Endangered Wildl

130 Young wildlife photographers

156 Index of photographers

Foreword

Hundreds of thousands of photographs were taken by photographers from 94 different countries. They picked the best of their collections and, between them, entered a record-breaking 43,135 pictures in this year's competition. Then the judges pulled out their favourites – the very best of the best – and what you see here is the astonishing result.

This book is the product of countless thousands of hours in the field, technical competence, exemplary fieldcraft, a lot of hard work, patience, passion, determination and, of course, a smattering of good luck.

Every year I think, surely, this time, we must have reached the pinnacle of perfection. How can the standard possibly get any higher? But somehow, yet again, the boundaries have been pushed and the bar raised to previously unimaginable high levels of sophistication, innovation and artistic vision.

This is partly a testament to improved technology. I have no doubt that the instant feedback offered by digital cameras, for instance, helps photographers to take better pictures. But that's not the only explanation. Wildlife photographers are definitely working harder than ever before, striving to capture a wider range of wildlife, locations and styles, tackling increasingly difficult subjects and shooting familiar ones in unfamiliar and more imaginative ways.

In recent years, I've been particularly impressed with the transformation of underwater photography. Again, digital has helped (for a start, underwater photographers are no longer restricted to a single roll of 36 shots per dive), but much of the credit must go to the photographers themselves. One way or another, they are taking pictures that stir the imagination and boggle the mind.

One of the most rewarding aspects of the competition is that it's not just professionals who are successful. This year, as every other year, many amateurs have triumphed, too, and lots of youngsters have proved themselves to be every bit as capable as their elders. The standard of images being produced by winners of the junior competition never ceases to amaze me. There are some outstanding up-and-coming photographers who'll be keeping the well-established pros on their toes for many years to come.

Leading the way in encouraging *responsible* wildlife photography, the competition frowns on those who harm or control the subjects of their pictures, and it doesn't accept images that have been manipulated in the computer. Fortunately, most wildlife photographers care about their subjects and are determined to represent them as faithfully as possible. Indeed, many of the winners are committed conservationists and use their images in an effort to safeguard the very animals, plants and wild places they photograph. What better outlet for their message than the Veolia Environnement Wildlife Photographer of the Year competition, which will be seen by millions of people worldwide?

Some of the images in this book will have an immediate impact on you – they'll leap off the page and lodge in your memory. Others will grow on you, as your eyes wander and explore. There will be a few you don't like as much as the others. But that's O.K. It's all part of the fun. Just imagine how boring it would be if we all agreed on every single image. Wildlife photography is as much about passion and personal preference as about technical perfection. So please judge to your heart's content but, most of all, enjoy.

Mark Carwardine, chair of the judges

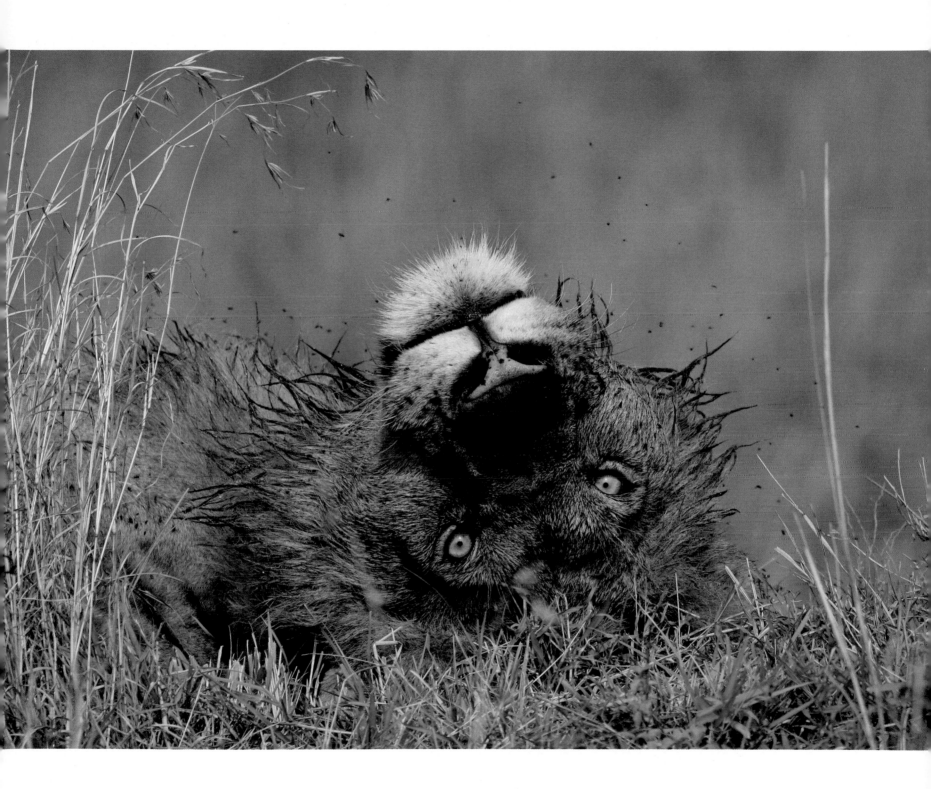

The competition

The pictures in this book are prize-winning and commended images from the 2009 Wildlife Photographer of the Year competition, sponsored this year by Veolia Environnement. The competition is *the* international showcase for the very best photography featuring natural subjects and is owned by two UK institutions that pride themselves on revealing and championing the diversity of life on Earth: the Natural History Museum and *BBC Wildlife Magazine*. This year, the collection represents the work of more than 80 professional and amateur photographers from all over the world.

Being recognized in this competition is something that wildlife photographers worldwide aspire to. Professionals win many of the prizes, but amateurs succeed, too. That's because the perfect picture is down to a mixture of vision, camera literacy, knowledge of nature – and luck. And such a mixture doesn't always require an armoury of equipment and global travel, as many of the pictures by young photographers reveal.

The international panel of judges, representing professionals from other media as well as photography, put aesthetic criteria above all others, looking for pictures with that creative element that takes a picture beyond just a representation of nature. They also place great emphasis on photographs taken in wild and free conditions, considering that the welfare of the subject is paramount.

The origins of the competition go back to 1964, when the magazine was called *Animals* and there were just 3 categories and about 600 entries. In 1981, it evolved into the form it takes now, and in 1984, *BBC Wildlife Magazine* and the Natural History Museum joined forces to create the international event it is today.

Now there are upwards of 40,000 entries (this year, 43,135), a major exhibition at the Natural History Museum and exhibitions touring throughout the year in the UK but also from the Americas through Europe and across to the Far East and Australasia. The pictures appear in *BBC Wildlife Magazine* and publications around the globe. As a result, the photographs are now seen by many millions of people.

The competition aims are
- to use its collection of inspirational photographs to make people worldwide wonder at the splendour, drama and variety of life on Earth;
- to inspire a new generation of photographic artists to produce visionary and expressive interpretations of nature;
- to be the world's most respected forum for wildlife photographic art, showcasing the very best photographic images of nature to a worldwide audience;
- to raise the status of wildlife photography into that of mainstream art.

Judges

Jim Brandenburg
photographer, film-maker and environmentalist

Mark Carwardine
(chair) zoologist, writer and photographer

Jack Dykinga
photographer

Laurent Geslin
photographer

Chris Gomersall
photographer

Orsolya Haarberg
photographer

Josef (Sepp) Hackhofer
photographer

Tim Harris
manager,
Nature and Garden Collections
Photoshot

Tony Heald
photographer

Rosamund Kidman Cox
editor and writer

Jan-Peter Lahall
photographer

Tor McIntosh
picture researcher/editor

Vincent Munier
photographer

Brian Skerry
marine photojournalist

Sophie Stafford
editor, *BBC Wildlife Magazine*

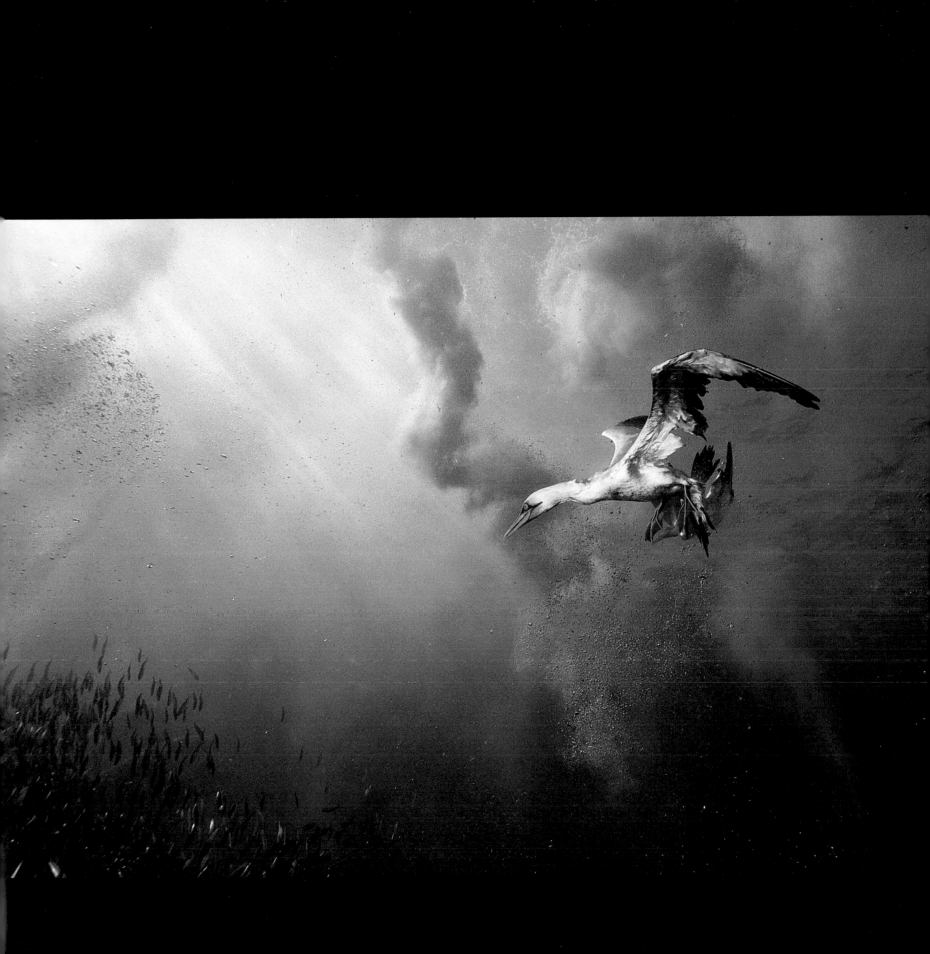

Organizers

The competition is owned by the Natural History Museum, London, and *BBC Wildlife Magazine*, and is sponsored by Veolia Environnement.

Open to visitors since 1881, the Natural History Museum looks after a world-class collection of 70 million specimens. It is also a leading scientific research institution, with groundbreaking projects in 70 or so countries. About 300 scientists work at the Museum, researching the valuable collections to better understand life on Earth, its ecosystems and the threats it faces.

Every year more than 3 million visitors, of all ages and levels of interest, are welcomed through the Museum's doors. They come to enjoy the many galleries and exhibitions, which celebrate the beauty and meaning of the natural world and encourage us to see the environment around us with new eyes.

Wildlife Photographer of the Year is one of the Museum's most successful and long-running exhibitions. Together with *BBC Wildlife Magazine*, the Museum has made it the most prestigious, innovative photographic competition of its kind and an international leader in the artistic representation of the natural world.

Last year's exhibition attracted a record 161,000 visitors, and more than a million others saw the images as they toured venues across the UK and internationally. People come to see the world's best wildlife photographs and gain an insight into the diversity of the natural world – an issue at the heart of our work.

Visit www.nhm.ac.uk
for what's on at the Museum.
You can also call +44 (0)20 7942 5000,
email information@nhm.ac.uk
or write to us at: Information Enquiries
The Natural History Museum
Cromwell Road, London SW7 5BD

For more than 40 years, the magazine has showcased the wonder and beauty of planet Earth, its animals and wild places – and highlighted its fragility.

By helping our community of more than 300,000 readers to understand, experience and enjoy the wildlife both close to home and abroad, we inspire them to care about the future of the natural world and take action to conserve it.

Every month, *BBC Wildlife* brings a world of wildlife to people's living rooms. We pride ourselves on our spectacular photography, and for this we rely on the photographers whose brilliance has been celebrated by the Wildlife Photographer of the Year competition since its launch in 1964.

Each issue includes page after page of beautiful photographs by the award-winning photographers, complete with the wild animals and even wilder stories behind them – and through their eyes we see the world's wildlife in all its glory.

You can take home all the winning images from Wildlife Photographer of the Year 2009 competition in our exhibition guide, free with our November issue.

Visit www.bbcwildlifemagazine.com
to find out more about *BBC Wildlife*, chat on our forum, download our podcast and show us your photos.
You can also call +44 (0)117 927 9009
or email wildlifemagazine@bbcmagazinesbristol.com

Subscribe to *BBC Wildlife Magazine*
to save 25 per cent on the shop price.
Call 0844 844 0251
or email wildlife@servicehelpline.co.uk
quoting WPOY09.

We are extremely proud to sponsor the Veolia Environnement Wildlife Photographer of the Year competition. Working with businesses, communities and governments across the world, we strive to improve the environment through the provision of integrated waste-management solutions. As such, it is our privilege to be the title sponsor for this year's competition.

Providing the right environmental services is our core business, and preserving natural habitats and animal species is essential to our present and future. This competition embodies the corporate values held by our company, such as our commitment to sustainable development, the preservation of natural resources and the very real need to educate and inspire people of all ages.

This competition not only features the best of wildlife photography from across the world but also highlights the richness and diversity of nature, which is our responsibility to protect.

Jean-Dominique Mallet
Chief Executive Officer
Veolia Environmental Services (UK Plc)
www.veoliaenvironmentalservices.co.uk

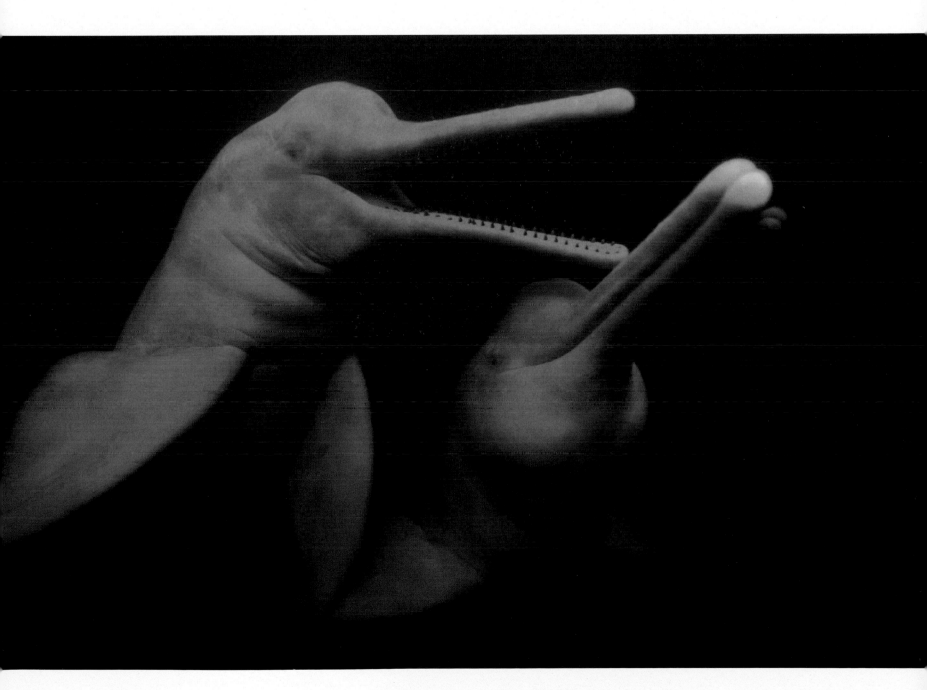

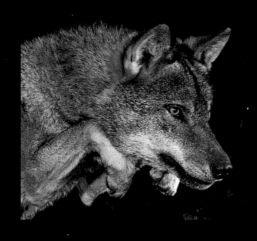

The Veolia Environnement
Wildlife Photographer of the Year Award

José Luis Rodríguez

 For the past 25 years, José Luis Rodríguez has been working as a nature photographer in Spain. He has published more than 40 books, is a regular contributor to nature and ecology magazines and has won many national and international awards. An expert on high-speed photography, José Luis is a pioneer of this technique in Spain, specializing in taking pictures of rare animals in motion. He runs the publishing company Fondo Natural and was the founder of the Spanish photo agency Nature & Travel and the agency Digital Wildlife.

The storybook wolf

José Luis visualized this image many years ago, when Iberian wolves first returned to Ávila in the Castilla y León region of northern Spain, and cattle ranchers declared war on them. His idea was a picture that would symbolize the ancient conflict between humans and wolves, while showing the beauty and strength of this fabled animal. But it took a long time to find the ideal location, let alone a wolf that would jump a gate. His chance came when he found a landowner who was happy to have both the wolves and José Luis on his property, and also had the ideal setting: a copse, an ancient, disused cattle corral and an old wooden gate.

José Luis started by placing meat in the corral. Once he knew a male wolf was visiting regularly, jumping the gate, he began to introduce the bits of equipment needed to set up a camera trap. At first, the wolf didn't like the flash triggered by the trip beam, but after a few weeks he took no notice of the light or the clicks of the hidden digital camera. Now that the wolf was happy and the camera positioning was right, it was time to take the final picture with a medium-format camera. When the first transparencies arrived back from the lab, José Luis was overjoyed to find he finally had the picture he had dreamt of. (See also page 64.)

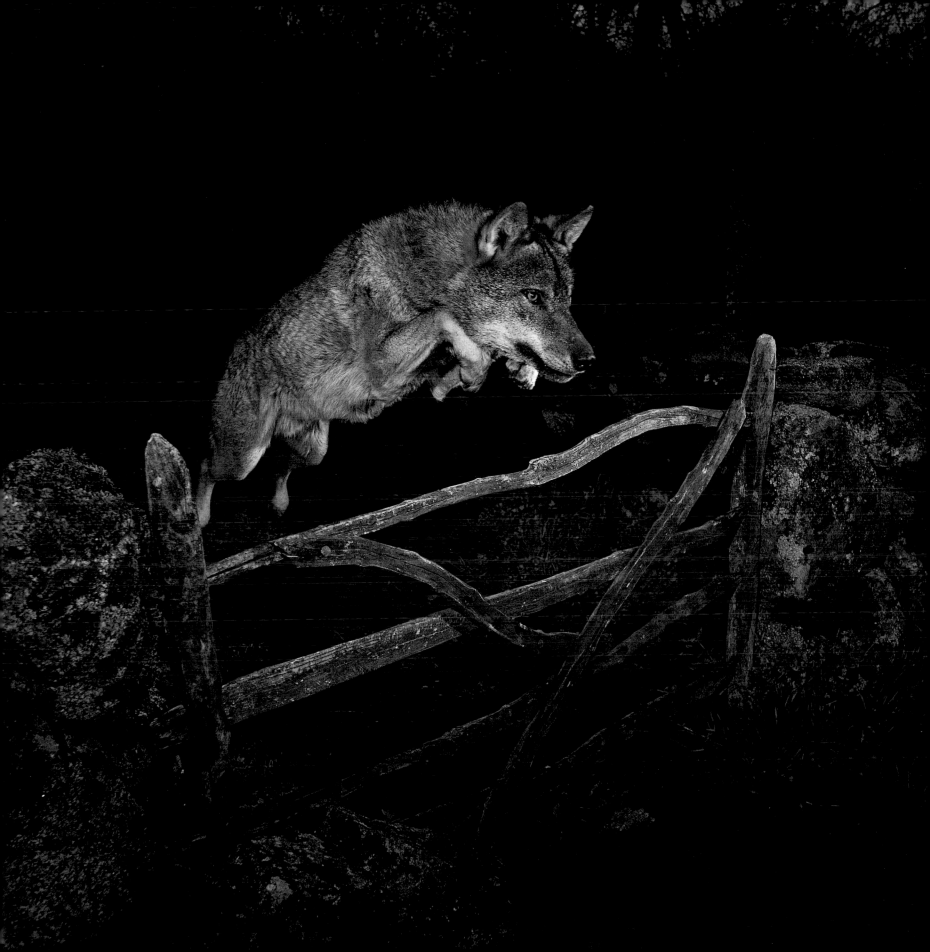

Creative Visions of Nature

The pictures here take inspiration from nature but reveal new ways of seeing natural subjects or scenes. They may be figurative, abstract or conceptual but must provoke thought or an emotional reaction, whether through their beauty or imaginative interpretation.

Fantail

WINNER

Esa Malkonen

FINLAND

There are probably only about a thousand bearded tits in Finland. Small groups live among reeds, and 'the best time to photograph them', says Esa, 'is in winter, when you can walk across the ice and get in among the rushes.' But they are not the easiest subjects. 'I sometimes spend an entire day on the frozen marshes,' says Esa, 'but while I don't see a glimpse of a tit, I often hear their voices ... The biggest challenge', he explains, 'is trying to photograph them flying among the reeds.' From the thousands of photos he took this winter, this shot of a tit landing on the ice is a favourite, 'its feathers fanned like the reeds.'

Canon EOS 50D + Canon 300mm f2.8 IS lens; 1/2000 sec at f5.6; ISO 400.

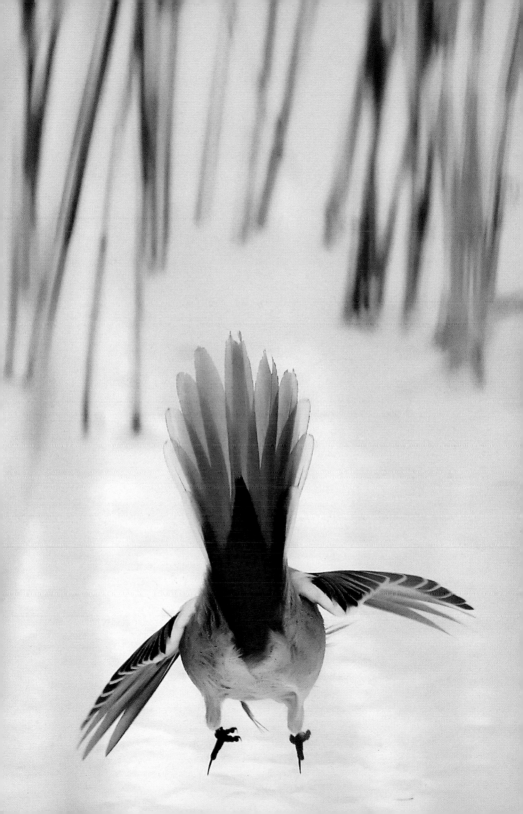

Illumination

RUNNER-UP

Xavier Coulmier

FRANCE

It was the end of a summer's day in the South of France. Beautiful demoiselles (damselflies) flitted across a small, sheltered brook. As the sun dropped towards the horizon, rays of light glanced off their wings, making them shimmer. Xavier's first thought was to try to photograph the demoiselles in flight with the light glinting off their wings. But when he looked through the viewfinder, he saw a very different world 'full of contrasts', of chaotic shards of light and dark, and the burnt sienna of the demoiselle's wings illuminated against the almost black-and-white environment. 'The scene lasted only a few seconds but profoundly moved me,' says Xavier.

Canon EOS-1Ds Mark II + Sigma 150mm f2.8 EX macro lens; 1/6400 sec at f2.8; ISO 100.

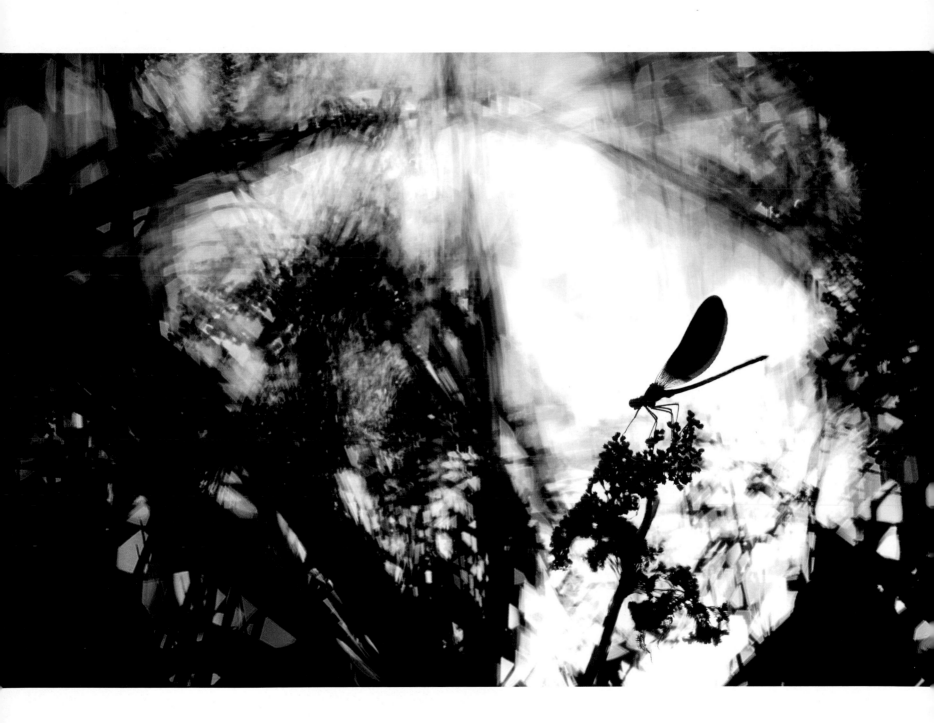

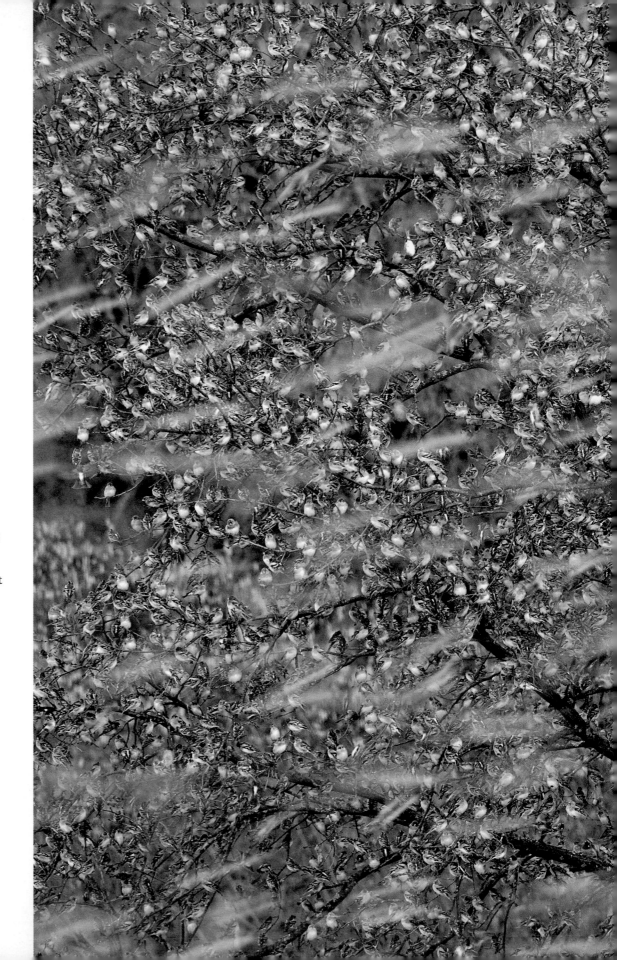

A settling of bramblings

SPECIALLY COMMENDED

Ewald Neffe

AUSTRIA

At first it's a blur, but then you start picking out the tiny birds. Last winter, close to four million bramblings arrived to roost in a forest in Steiermark, Austria. Ewald watched in disbelief as the bramblings poured in from all directions, circling close to the ground before settling. They sat together on the trees, as though exchanging stories about their day, before moving further into the wood. Ewald solved the problem of dim light and moving branches by using a slow shutter-speed, which both captured the movement and gave a feel of the multitude of birds.

Nikon D300 + Nikon 200-400mm lens; 1/40 sec at f5.6; ISO 400.

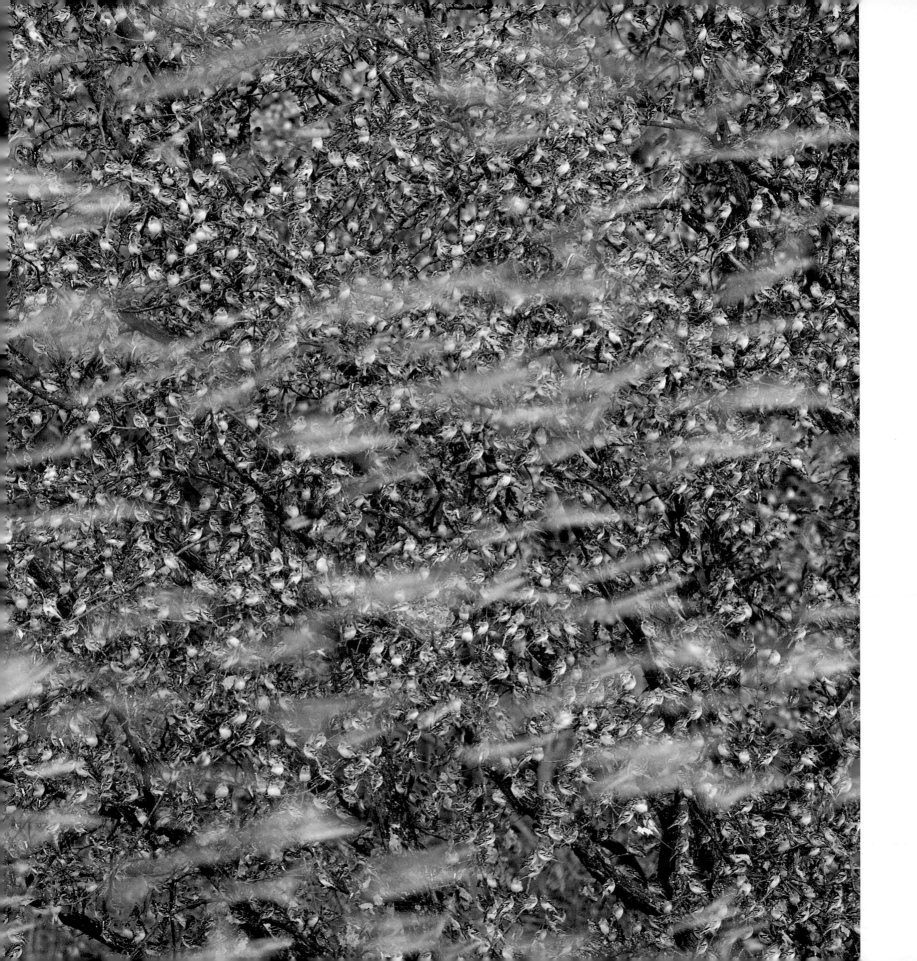

The filter-feeding forest

HIGHLY COMMENDED

Lawrence Alex Wu

CANADA

This is what it looks like inside a sea squirt's 'mouth': a forest of water filters. Surprisingly for this urn-shaped animal, the sea squirt has a very primitive form of spinal cord, the notochord, and is therefore classified as a very distant relative of animals with backbones. This species of sea squirt, photographed in the Philippines, is fairly common in tropical waters. It feeds by pumping in water through its intake and exit holes and trapping food particles in these tree-like filters. Living symbiotically inside the filter forest are microbes (prochlorons) containing green chlorophyll, which photosynthesize like plants and are responsible for the magnificent green coloration. 'I'd had glimpses inside these sea squirts over the years,' says Alex, 'but it took a while before I found an individual with a gape big enough to enable me get such an otherworldly image.'

Olympus C5050Z; 1/200 sec at f8; ISO 64; Ikelite DS125 housing; Inon Z-220 strobes.

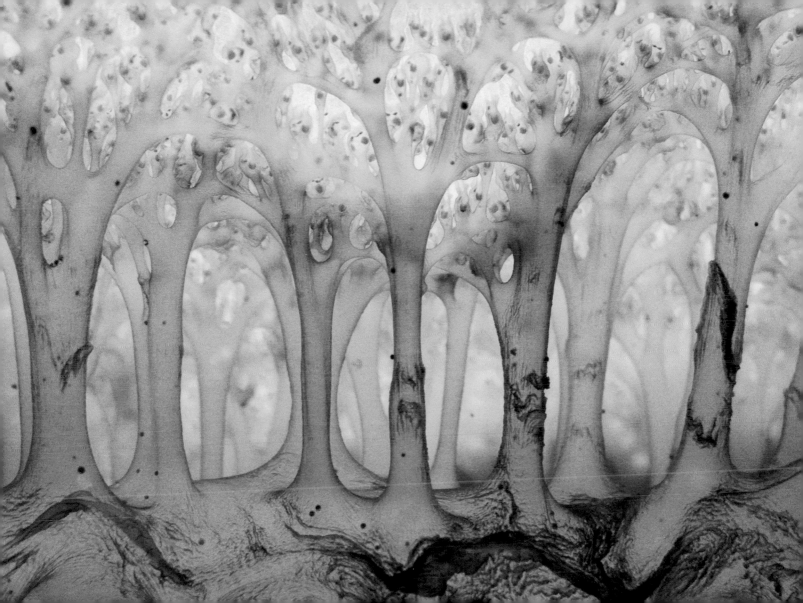

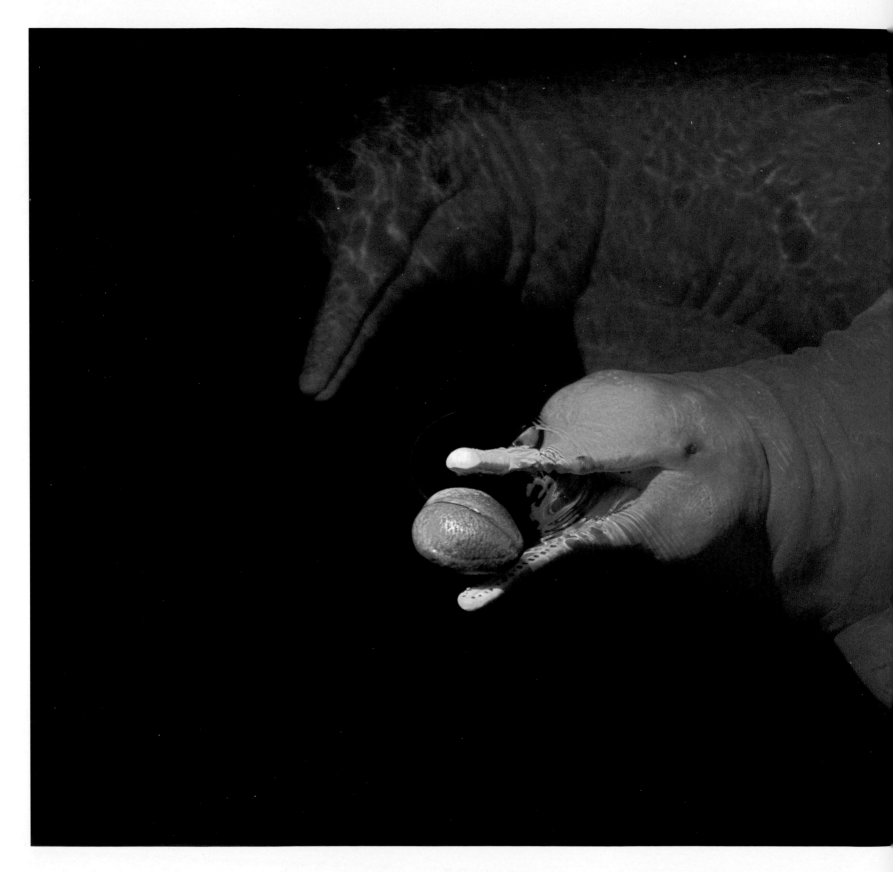

Behaviour
Mammals

These pictures are chosen for their action and interest value as well as for their aesthetic appeal.

Boto water polo

WINNER

Kevin Schafer

USA

A pair of wild Amazon river dolphins, or botos, play with a floating macucu seed in a tributary of the Rio Negro in Amazonian Brazil. In the tannin-rich water of silt and rotting vegetation they appear almost orange, though their actual colour ranges from grey to pink. 'Often in the afternoon,' says Kevin, 'I noticed that they stopped feeding and took time to play with objects, sometimes picking them up and throwing them like a game of dolphin water polo.' Some scientists believe that the players are male dolphins showing off to females. 'I saw this behaviour many times,' says Kevin, 'but it took the construction of a floating platform above the river to be able to shoot the action from the right angle.'

Nikon D3 + Nikon 70-200mm lens; 1/320 sec at f5.6; ISO 1000.

Leopard descending

RUNNER-UP

Ajit K. Huilgol

INDIA

Driving along a twisty track in Nagarhole National Park in southern India, Ajit didn't see the leopard until he was almost at the tree – rather, he spotted her flicking tail hanging down like a bell-rope. In the thick forests of southern India, leopard sightings are rare, and ones lasting more than a few moments are rarer still. Draped over a branch, the female posed for Ajit 'like a professional model' for a full 20 minutes. The end of the show was signalled by the sound of a vehicle. But instead of leaping from the tree, she swept straight down the trunk 'with a grace that was truly sublime'.

Canon EOS-1D Mark III + Canon 500mm lens; 1/80 sec at f8; ISO 400.

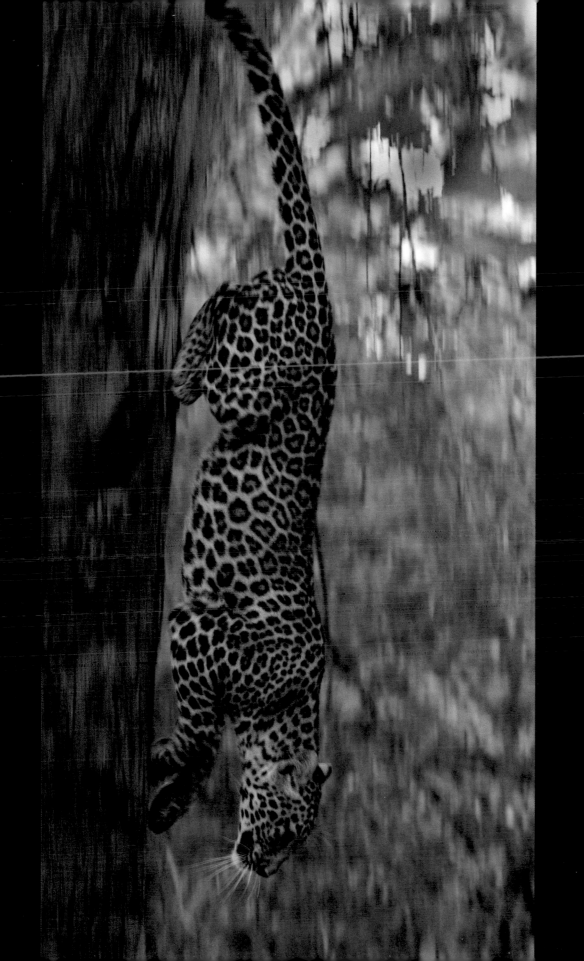

Hare spat

RUNNER-UP

Morten Hilmer

DENMARK

The only way for Morten to stay in the world's biggest national park for any decent length of time was to take a job as a cook at the isolated Danmarkshavn weather station in northeast Greenland. For three months, he spent half a day catering for the seven staff. The rest of the day, he headed out into the nearby mountains, gradually getting to know the daily routines of the local Arctic hares. In the station kitchen, there were plenty of rations. But out in the frozen wilds, it was a different story. The hares had to scrape away the snow to reach the roots below. With food so scarce, tempers ran high, and squabbles often broke out. This explosive spat, backlit by the setting sun, was over in seconds – since at temperatures below -25°C (32°F), energy was too precious to waste. The hares did, though, have strategies to cope: sometimes, when the weather-station dogs dozed, they would creep up and pinch their food.

Nikon D2X + AF-S Nikkor 200-400mm f4 lens; 1/500 sec at f4; ISO 160.

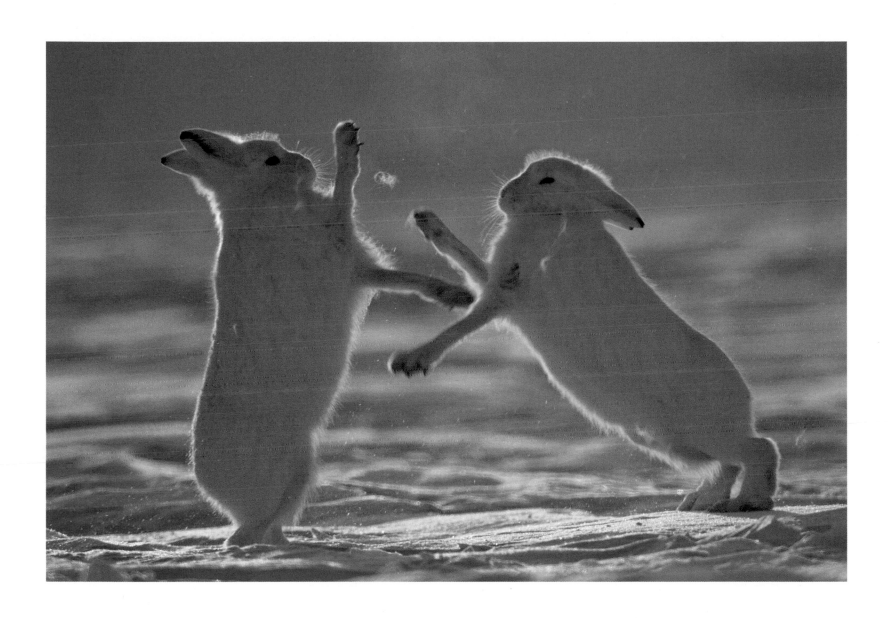

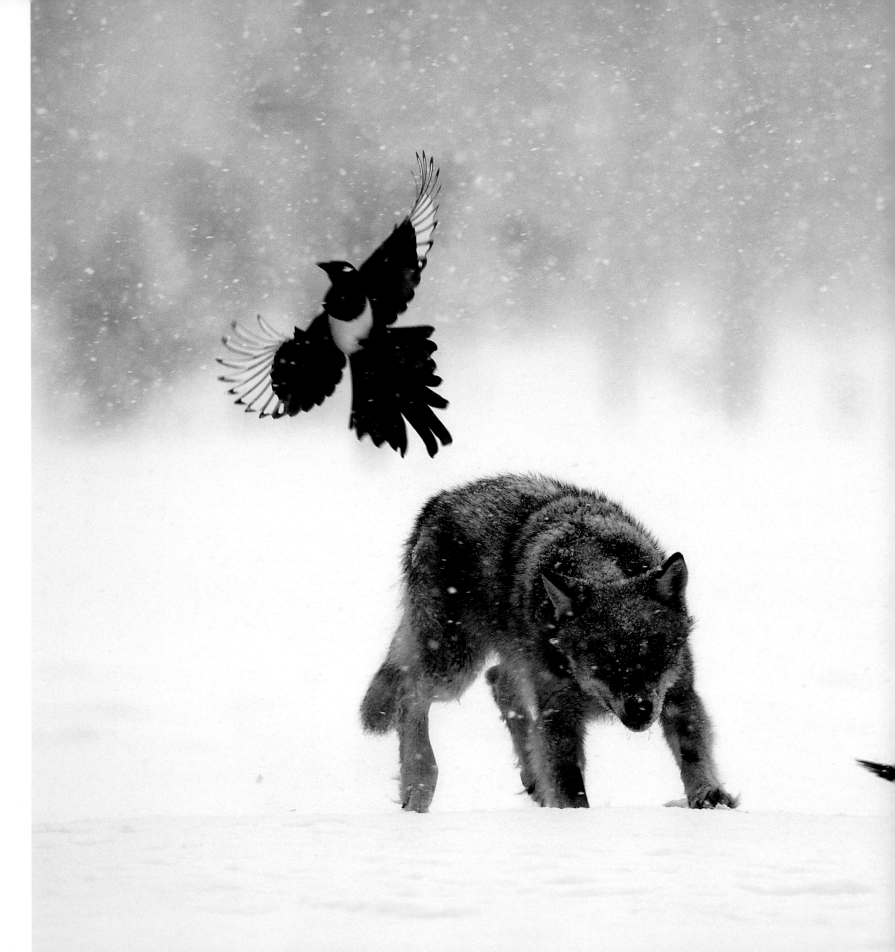

Seeing off the raiders

HIGHLY COMMENDED

Seppo Pöllänen

FINLAND

This picture was taken in Kuhmo, eastern Finland, on the Russian border – a hotspot for wolves and wolverines. Seppo spent four days in February in a hide waiting for carnivores to come to the bait he had put down. 'I'd seen wolves three times from the hide,' says Seppo, 'but very early in the morning, with insufficient light to take photos. I was thrilled when this young wolf finally turned up.' He was irritated by the magpies and ravens trying to snatch pieces of meat, and he suddenly turned on them, giving Seppo the action picture he had been hoping for.

Canon EOS-1Ds Mark III + Canon EF 800mm f5.6 IS USM lens; 1/640 sec at f8; ISO 800; RRS Ball Head + Wimberley Sidekick.

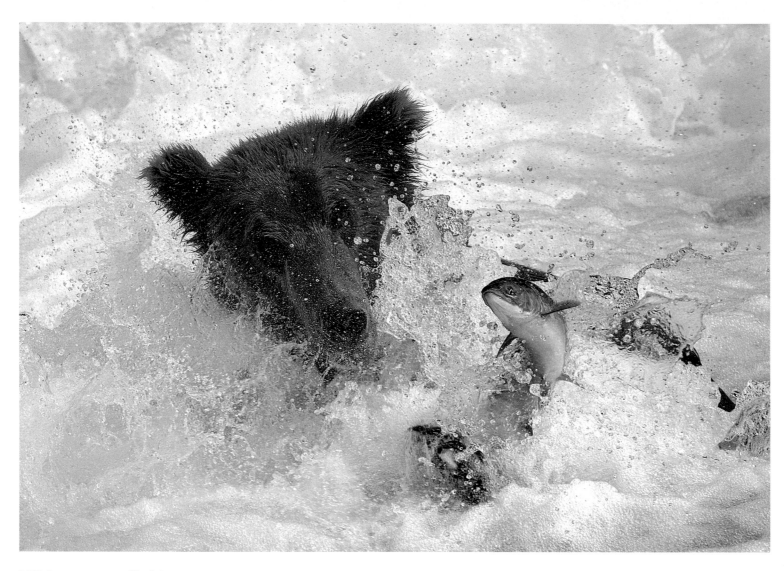

White-water fishing

HIGHLY COMMENDED

Eric Lefranc

FRANCE

Some of the brown bears fishing the salmon run at the Brooks Falls in Katmai National Park, Alaska, were waiting at the top of the falls, others were sitting at the bottom catching salmon before they jumped, and a few big bears were simply stealing catches from young ones. Eric focused on a young bear in a turbulent spot below the falls. Neck-high in water, it spent the day pouncing, with varying success. What Eric especially liked about this shot is the intensity in the eyes of the salmon – which escaped.

Nikon D300 + AF-S Nikkor 400mm f2.8 VR lens; 1/1000 sec at f8; ISO 280; Gitzo tripod 5540LS + Wimberley Head.

Big cat fight

HIGHLY COMMENDED

Andy Rouse

UNITED KINGDOM

This was no play-fight. Claws fully extended, Machali battered her young rival. 'I've never seen anything like it,' says Andy. 'She raked her claws down her opponent's flesh, and then pounded her to the ground. The noise was incredible – the most violent, amplified cat-fight yowling you've ever heard. It was terrifying.' Through fury and sheer power, Machali (left) drove off her rival. But the young female, barely two years old, is still intruding into Machali's territory in India's Ranthambore National Park. And that's because she is Machali's own daughter.

Nikon D3 + Nikon 200-400mm lens; 1/800 sec at f4; ISO 2000.

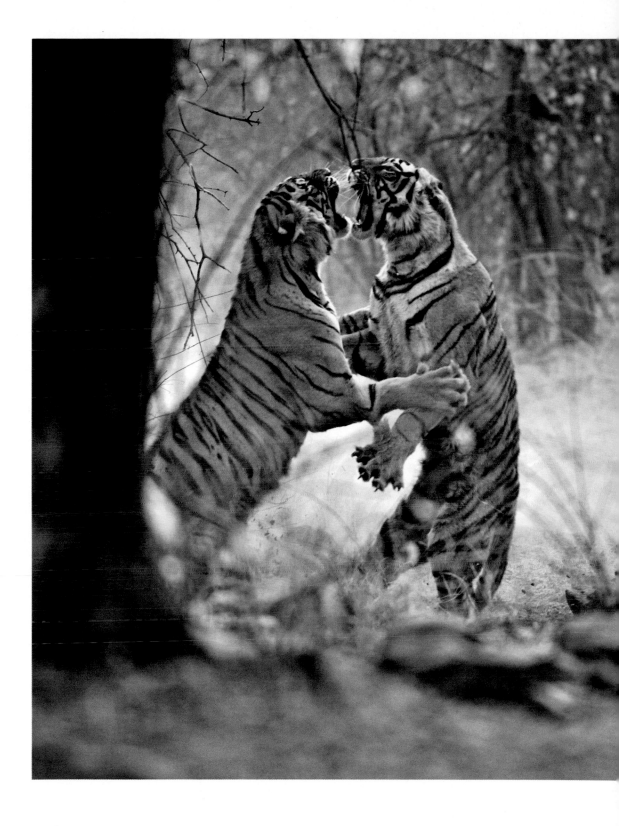

Courtship race

HIGHLY COMMENDED

Janne Heimonen

FINLAND

Janne got his coat, put the dog on its lead and went out the back of his house in Jyväskylä, central Finland. He'd barely set foot along the path when he saw these two brown hares bounding across the snowy field behind. They were so focused on their courtship that Janne had time to nip back indoors and grab his camera. 'The male was determined to mate. He even tried to hold her fur with his teeth. And she wasn't trying that hard to get away,' he remembers. 'Sometimes, she would sit down, but when he tried to mate, she would get up and run off again.' The hares eventually disappeared into a thicket, and the dog finally got its evening walk.

Canon EOS 20D + Canon EF 300mm f2.8L IS USM lens at 600mm with 2x teleconverter; 1/500 sec at f5.6; ISO 400.

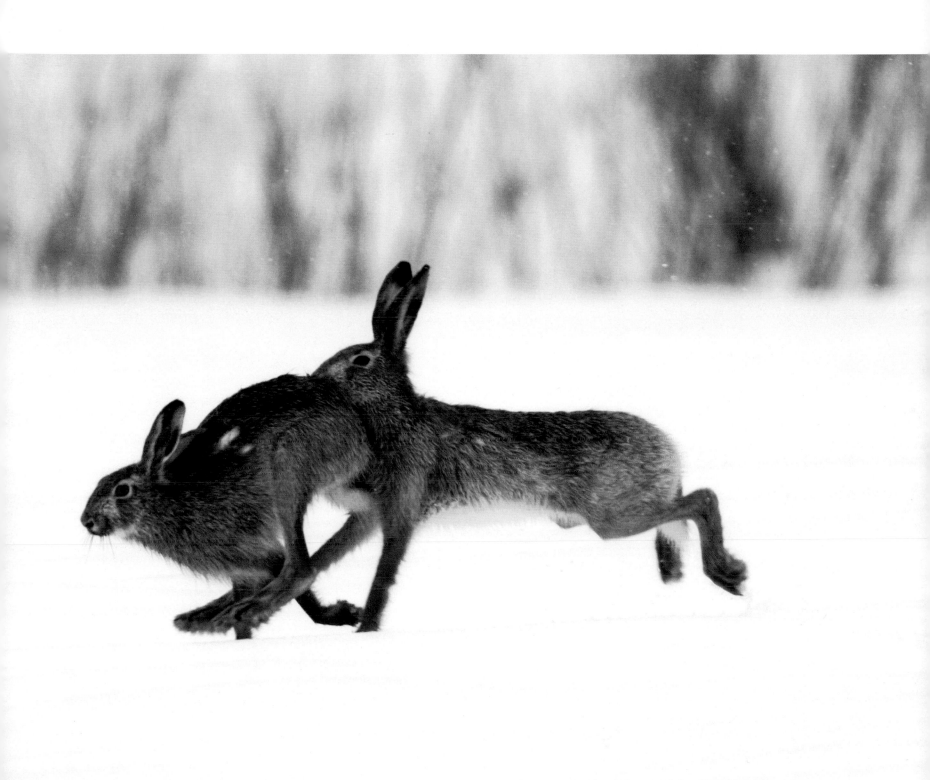

Behaviour
Birds

Birds are hugely popular subjects for photographers. The challenge is to take a picture that has both aesthetic appeal and shows active or interesting behaviour.

Opportunist snatch

WINNER

Rob Palmer

USA

In January 2009, something strange happened at a cattle feedlot in Colorado. Rob noticed a group of bald eagles sitting in a large tree nearby. Usually, bald eagles hunt near water. Usually, they eat fish – but they are also opportunists. These ones had gathered to feed on starlings and red-winged blackbirds and would launch themselves out of the trees and chase the small birds up into the sky. In this case, the eagle (an immature) was successful, but often the small birds would out-fly their attackers. What was strange was the way some of the small birds would suddenly fly up in an erratic way, making themselves easy targets. What Rob suspects is that the cattle feed may have been treated with an avicide (a bird poison) that affected the birds' nervous systems. But after two weeks, the odd behaviour of the small birds stopped, and within a few days, the bald eagles left.

Canon EOS-1Ds Mark III + Canon 500mm f4 IS USM lens; 1/3200 sec at f5; ISO 400.

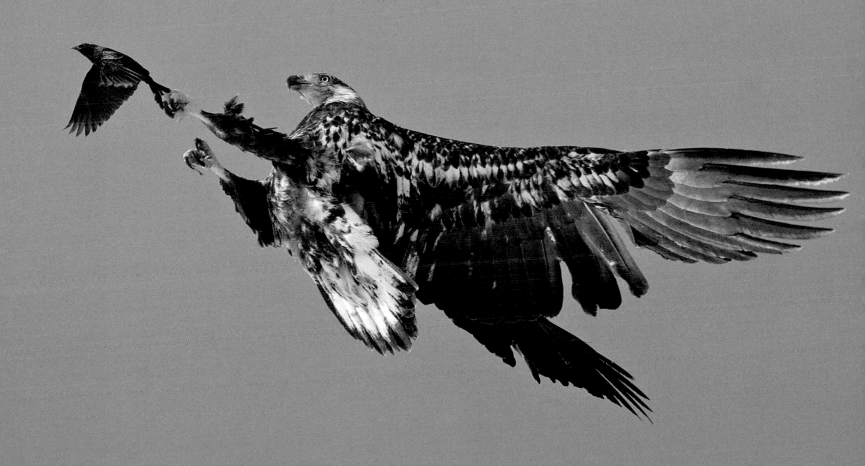

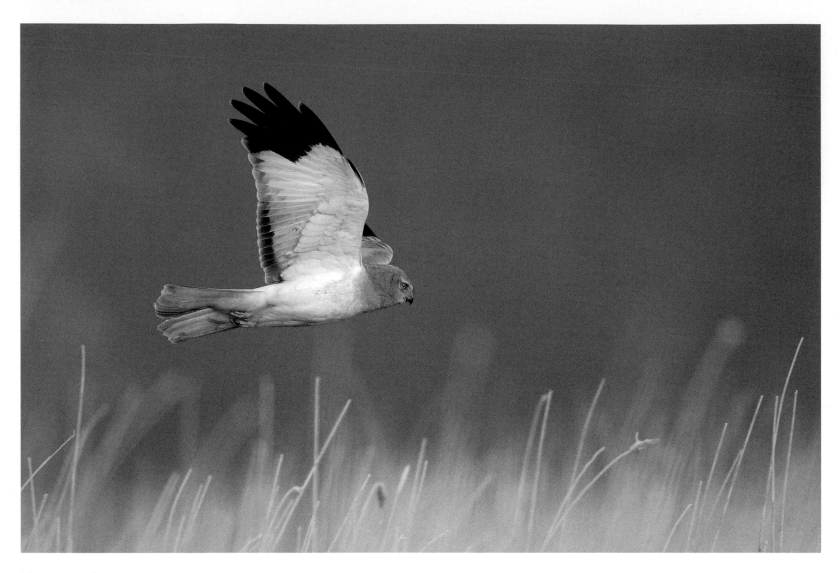

Hunting harrier

HIGHLY COMMENDED

Marc Slootmaekers

BELGIUM

In winter, male hen harriers try to stay near their breeding grounds. But last year's bitter cold forced this male to move south to Kalmthoutse Heide nature reserve in Flanders, where Marc does most of his photography. Having worked out the bird's routine, Marc positioned his hide and arrived just before dawn. As the mist rose, the male came into view cruising over the frost-covered grass, cocking his head to listen for mice, 'spot-lit against the grey sky,' says Marc, 'his yellow feet and eye glowing.'

Canon EOS 50D + 500mm lens; 1/1600 sec at f4; ISO 400; Gitzo tripod + Manfrotto 503 Fluid Head.

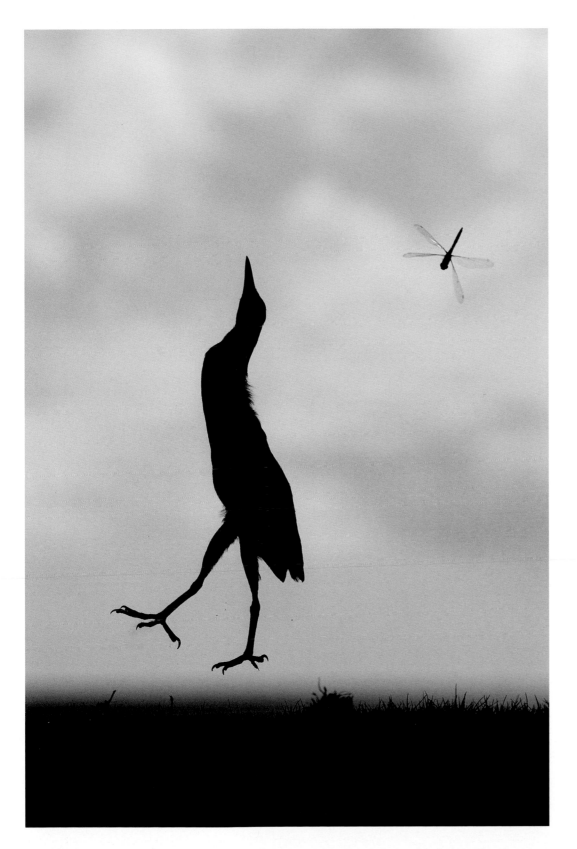

Leaping heron

RUNNER-UP

Thomas P. Peschak

SOUTH AFRICA

Green-backed herons normally catch fish, but some seem to be partial to insects, too. Tom spent a month on Aldabra in the Seychelles, where he encountered this heron, intent on catching dragonflies. Impressed by its valiant efforts, he settled down to photograph it. 'The little heron's hunting success rate can best be described as fair,' says Tom. 'Fewer than a third of its acrobatic leaps resulted in a catch.' Nonetheless, it persisted until the sun started to set, which created the soft background lighting for this near-final shot. Tom was so enchanted that he planned to photograph the bird again from a different angle the next day. But he never witnessed this behaviour again in all the time he was on Aldabra.

Nikon D3 + 70-200mm f2.8 lens; 1/3200 sec at f6.3; ISO 400.

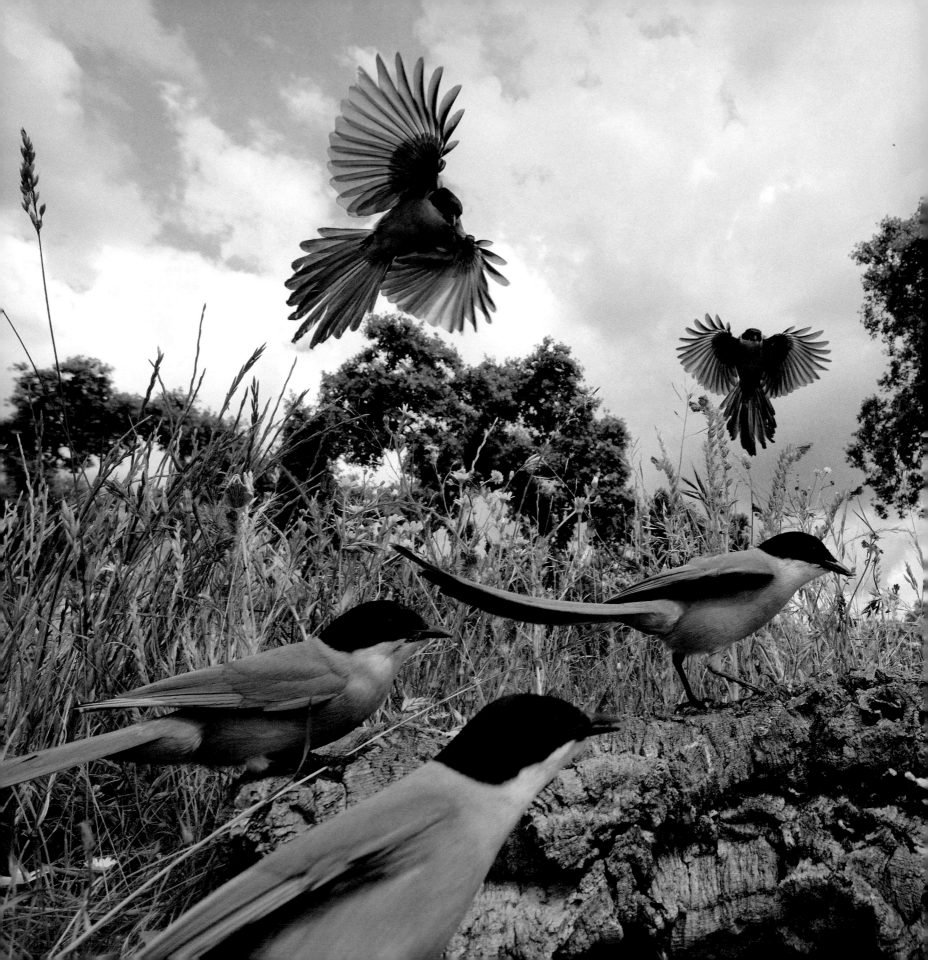

Azure-winged gathering

HIGHLY COMMENDED

Gertjan de Zoete

THE NETHERLANDS

Whenever these azure-winged magpies sounded the alarm, Gertjan didn't even need to look up to see what raptor they were referring to. He'd spent so much time with them that he knew as well as they did the difference between a black kite warning call (little danger) or a booted eagle one (big danger). The vocabulary of these garrulous birds also includes an easy-to-recognize food call. By baiting an area of flowering *dehesa* (a meadow ecosystem studded with ancient holm oaks and cork trees) in Extremadura, Spain, Gertjan had plenty of opportunity to hear that. The sociable birds became so trusting that they even ended up sitting on his camera.

Nikon D3 + Nikon 14-24mm lens at 17mm; 1/2000 sec at f10; ISO 1600; infrared release.

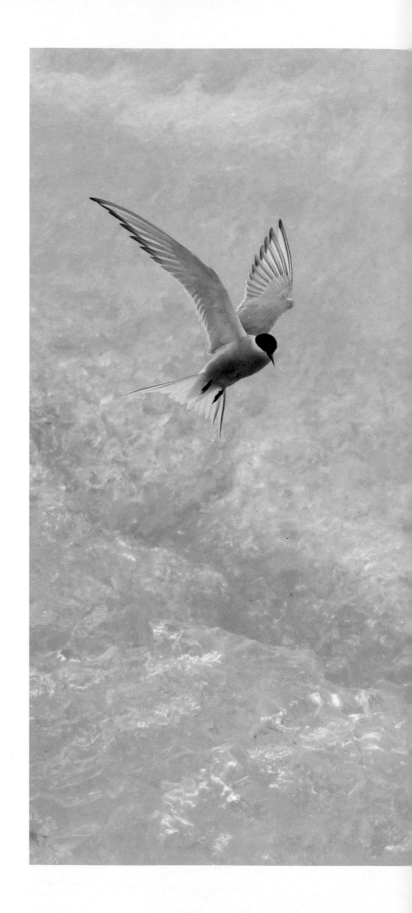

Terns in a dive queue

HIGHLY COMMENDED

Paul Sansome

UNITED KINGDOM

Jökulsárlón in the southeast of Iceland is a landscape photographer's dream location, with a mountainous backdrop from which flows the dramatic Breidamerkurjokull Glacier, calving icebergs into a huge lagoon. But what distracted Paul were the Arctic terns breeding around the lagoon. When fishing, they hover around the entrance, and as the tide comes in and the lagoon fills with small fish, the birds target their prey, screeching, swooping and diving. What caught Paul's attention were four terns lined up for a dive. Suddenly, the grey-cloud backdrop was replaced by a blue iceberg sliding silently behind them. Paul had just a minute or so in which to photograph the group. 'I'm sure I could return a hundred times and never witness this composition again,' says Paul.

Canon EOS-5D + Canon 500mm f4.5 lens; 1/4000 sec at f4.5; ISO 400.

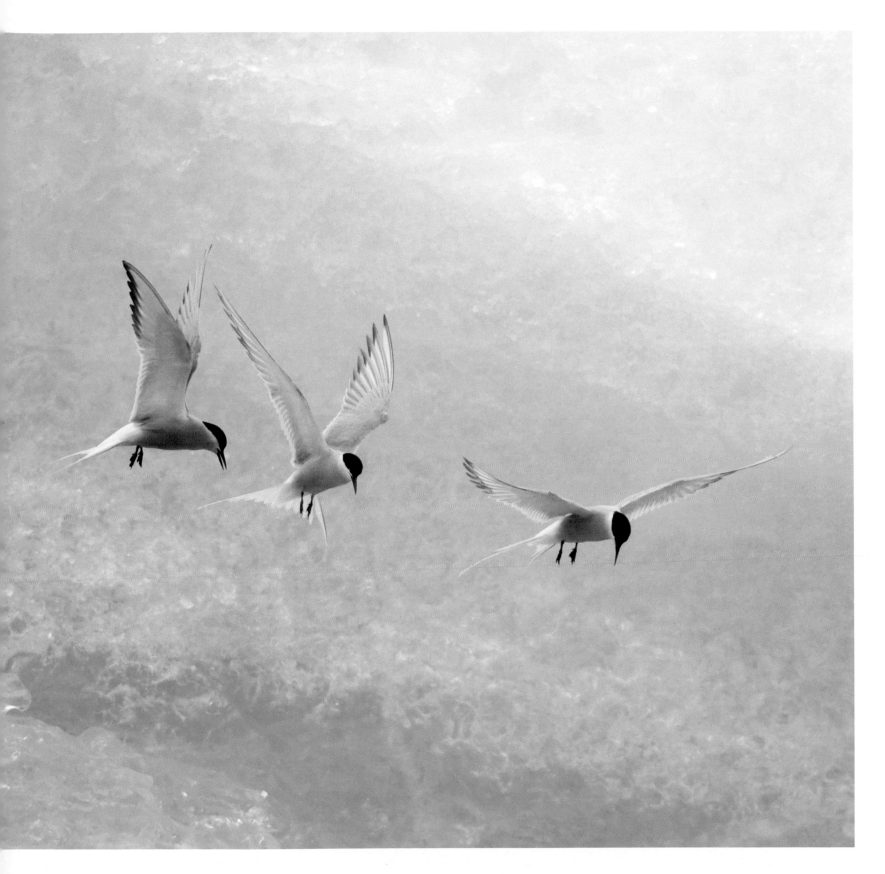

Behaviour
All Other
Animals

This is a category for pictures of animals that are not mammals or birds – in other words, the majority of animals on Earth. Most of them behave in ways that are seldom witnessed and little known or understood. So this category offers plenty of scope for fascinating behaviour.

Raindrop refresher

WINNER

András Mészáros

HUNGARY

After a summer shower, András headed off to his local forest to take photographs. He specializes in pictures taken around his home near Lake Velence in Hungary – in particular, close-ups. In a sunny glade, he noticed lots of red ants running up and down a flowering common mallow, feeding on the sugar secretions of aphids sucking from the buds. Here, one of the ants sips from a raindrop balanced on a mallow petal. 'The beauty of macro-photography,' says András, 'is the worlds it reveals – all the activity going on in miniature that you otherwise would never see.'

Canon EOS-5D + Canon EF 50mm f1.8 lens reversed + 2 sets of extension tubes + Canon EF 1.4x teleconverter; 1/200 sec at f9; ISO 200; Gitzo 143 tripod + Manfrotto 469 Ball Head; Canon 420EX flash; beanbag

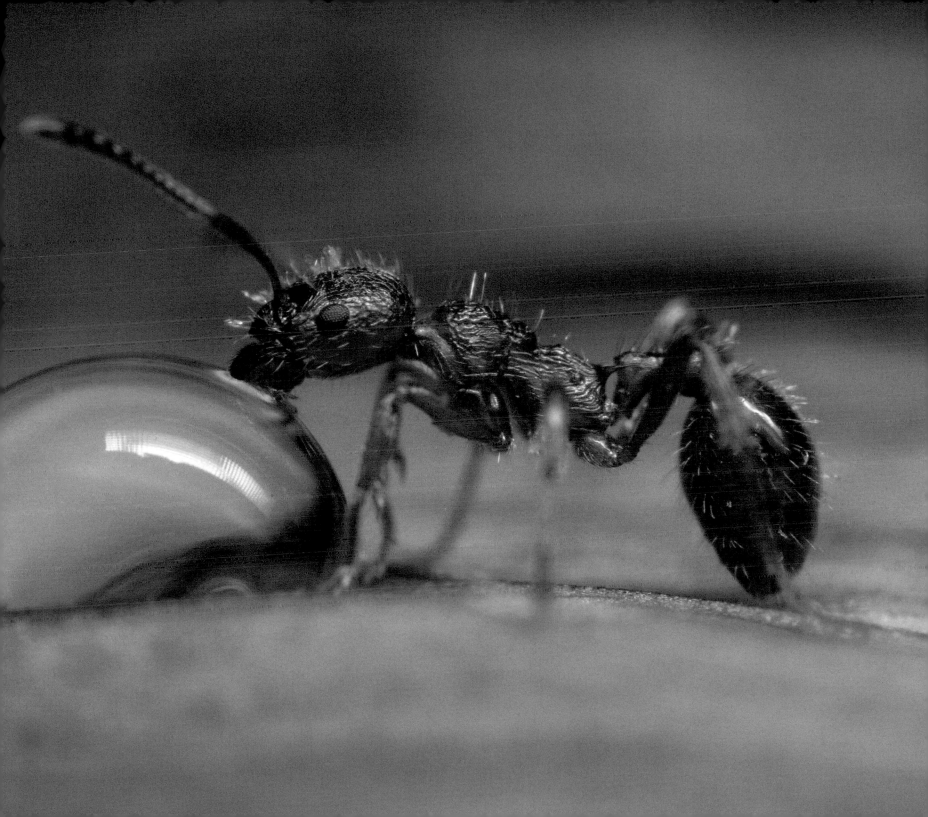

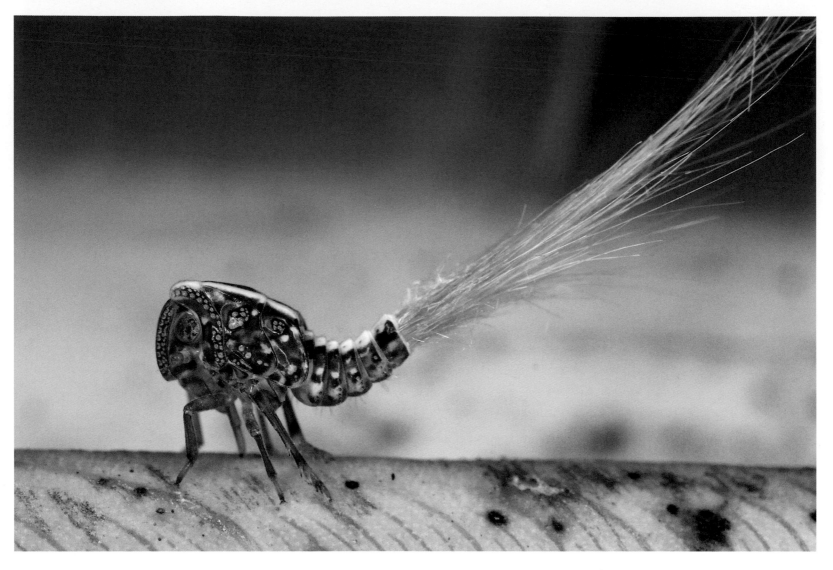

Little hopper

HIGHLY COMMENDED

Alexandr Pospěch

CZECH REPUBLIC

Even when the mosquitoes bit, Alexandr didn't move. He didn't dare take his eye from the viewfinder – the plant-hopper larva was so tiny (just millimetres long) and so active. He'd spotted it on a banana leaf in forest in Papua New Guinea and spent about half an hour trying to photograph it. The tiny larva feeds by piercing the leaf with its needle-like stylet and sucking the sap. The filaments sticking up from its rear end may serve to confuse or distract predators, but no one knows for sure.

Canon EOS 40D + Canon MP-E65mm f2.8 1.5x macro lens; 1/250 sec at f11.3; ISO 100; flash.

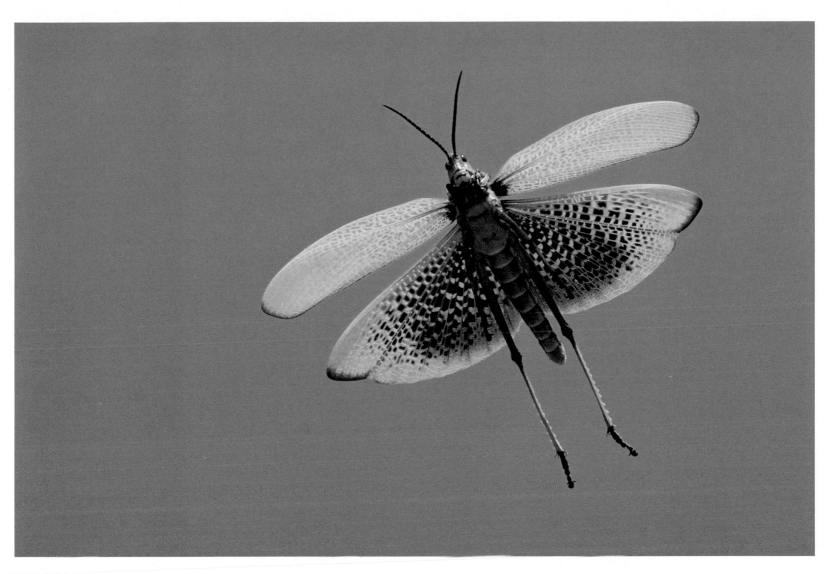

Flight of the locust

RUNNER-UP

Chris van Rooyen

SOUTH AFRICA

The intention had been to photograph Verreaux's eagles breeding in nearby botanic gardens in Gauteng, South Africa. But then something unexpected happened. Shortly after he arrived, the sky filled with locusts on migration eastwards. 'The flight went on for hours,' says Chris. 'Against the blue sky, the green milkweed locusts were beautiful.' Using a medium telephoto lens, he photographed this one displaying its rainbow colours as it passed overhead.

Canon EOS-1D Mark II + Canon EF 300mm f4 IS USM lens; 1/4000 sec at f5.6; ISO 400.

Sardine round-up

HIGHLY COMMENDED

Paul Nicklen

CANADA

The Atlantic sailfish is probably the most prized sport fish in the world, but very little is known about its behaviour other than that it is the fastest swimming fish on record, reaching speeds of up to 109kph (68mph). As Paul discovered on this photographic assignment off Mexico's Yucatán Peninsula, it's not just the speed of sailfish that's impressive but also their technique for catching their favourite prey, sardines. 'Approaching a school of fish, sailfish work together like marine mammals, coordinating to corral the bait into a tight ball with the use of their raised sails, confusing their prey with their fast-changing colours. They then dive into the baitball, slicing from side to side with their razor-sharp bills, wounding and isolating fish. Taking it in turns, they drive the ball towards the surface until the sardines are exhausted and are easy prey.'

Canon EOS-1Ds Mark II + Canon EF 16-35mm f2.8L II USM lens; 1/250 sec at f8; ISO 400; Ikelite strobes; Seacam housing.

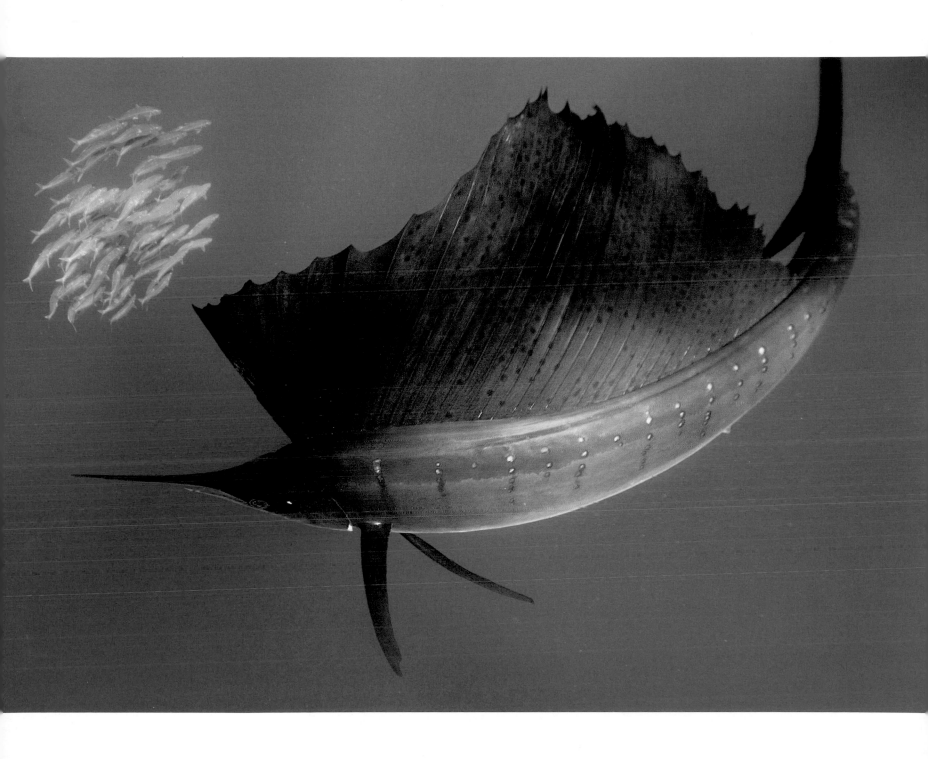

Nature in Black and White

What pictures here must display is skilful and artistic use of the black-and-white medium. The subject can be any wild landscape or creature.

Starling wave

WINNER

Danny Green

UNITED KINGDOM

Starling populations in the UK swell in December and January as birds from the Continent head for milder wintering areas. Huge flocks roost in many spots throughout the country, and as Danny has been working on a long-term project to photograph these impressive roosts, he has visited most of them. 'This gathering,' says Danny, 'was by far the most impressive I have ever seen.' The location was Gretna Green, Scotland. The stage was set: a perfect evening, hundreds upon thousands of starlings. And then the main character appeared, off stage-left – a peregrine falcon, which sent ripples of pulsating panic throughout the entire flock. 'I used a slow shutter-speed,' says Danny, 'so I could accentuate this lovely sweeping movement as the birds exploded over farmland and trees to escape the hunting peregrine.'

Canon EOS-1Ds Mark II + Canon 70-200mm lens; 1/3 sec at f2.8; ISO 400.

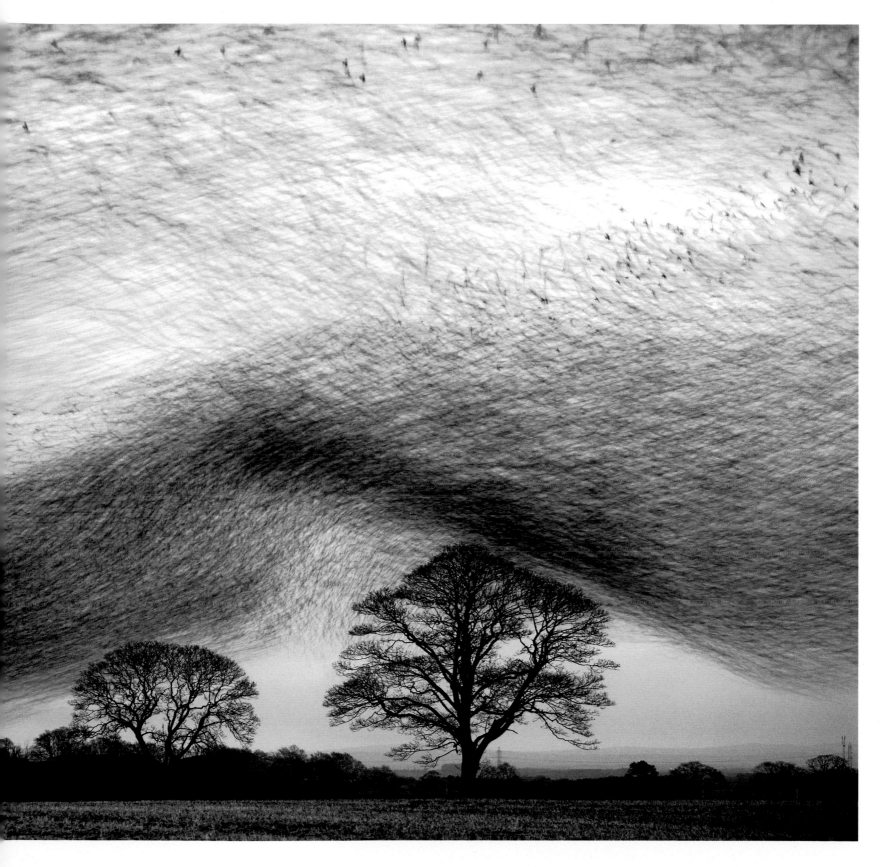

Black woodpecker in grey

RUNNER-UP

David Hackel
and Michel Poinsignon

FRANCE

This beech tree, in an ancient forest in the Vosges mountains in eastern France, has been home to black woodpeckers for a number of years. When one nest-hole was abandoned two years ago, it was immediately occupied by Tengmalm's owls, who raised a brood of at least five chicks. But just 60cm (2 feet) below, the black woodpeckers nested in another hole, in which they successfully fledged three chicks. The following year, David and Michel erected a scaffolding hide 6 metres (20 feet) high on a slope facing the tree, on a level with the woodpecker nest-hole. They then set about documenting the birds' activities. One day, the rain was so unrelenting that a thick mist filled the forest. Though there was almost no visibility, the atmosphere of mystery it created resulted in their favourite picture of the whole period.

Nikon D200 + Nikon 17-55mm f2.8G lens at 55mm; 1/1000 sec at f6.3; ISO 400.

The fairy companion

SPECIALLY COMMENDED
Daisy Gilardini
SWITZERLAND

Daisy was on Midway Atoll in the Pacific specifically to photograph the birdlife. 'On my first day,' says Daisy, 'while exploring by bike, I heard something flying close behind me.' To her huge surprise, a group of fairy terns was trailing her. Cycling to the pier to photograph birds, with the terns following behind, became part of Daisy's routine. 'They really seemed to want to interact.' This tern 'looked at me so intently,' says Daisy, 'it was almost as if it had something vitally important to tell me.'

Lone lion

HIGHLY COMMENDED

Britta Jaschinski

GERMANY

Britta heard tales of a solitary old lion wandering in the Lobo area of Tanzania's Serengeti National Park. Fascinated, she spent three days searching for him and found him resting in the shade of an acacia tree. No one was sure what had happened to him, though he may have been forced from his pride by a younger male. 'His face seemed to bear the weight of wide experience. An old, wise beast. Enormously powerful, but lost perhaps – for a moment – in his own solitude.'

Nikon FG + 200mm lens; 1/250 sec at f5.6; Polaroid 35mm high-contrast black-and-white instant film ISO 400.

Crossing frenzy

HIGHLY COMMENDED

Greg du Toit

SOUTH AFRICA

Each year between July and October,
approximately one and a half million wildebeest
migrate into Kenya's Masai Mara Game Reserve
in search of fresh grass. They have to cross
the River Mara and run the gauntlet of not only
Nile crocodiles but also the herd itself, with
the risk of being trampled and drowned.
'The build-up to a river crossing is electric,' says
Greg. 'I wanted to capture that frenzied energy
and panic.' He waited for more than two hours
while the nervous herd assembled on the far bank.
The light had almost gone when the first brave
wildebeest took the plunge. Then all hell let loose.
Greg waited a fraction of a second for the lead
animal to emerge from the water before pressing
the shutter – and taking the image he was after.

Nikon D200 + Nikon 80-400mm f5.6 lens; 1/5 sec at f8
(-1 e/v); ISO 200.

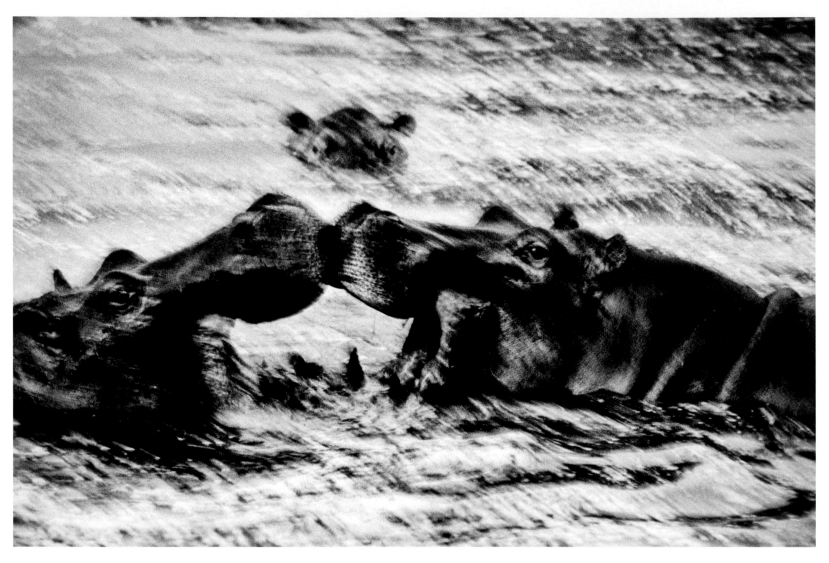

Clash of the Titans

HIGHLY COMMENDED

Sheri Mandel

USA

When Sheri arrived at the pool in the Serengeti, two male hippos were squaring up. One began scooping up enormous mouthfuls of water and then lunged at his rival. 'Their gaping jaws slammed into each other and waves crashed around them,' says Sheri. 'I was transfixed by the brute force and chaos.' Then it began to rain. The light was almost gone and her guide was urging her back to the car when the third hippo emerged in the centre of her viewfinder. Sheri knew then she had her image.

Canon EOS 1V + Canon 100-400mm L IS USM lens + EF 1.4x II extender; 1/100 sec at f8; Fujichrome Velvia 100.

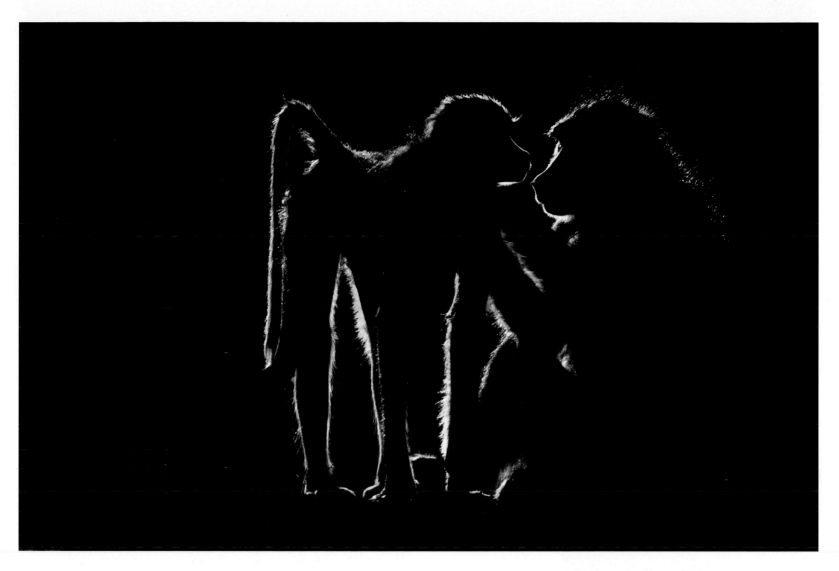

Baboon bonding

HIGHLY COMMENDED

Patrick Bentley

ZAMBIA

Lost in his task, this male yellow baboon grooms a female, gently combing through her fur to pick out parasites and particles of skin and dust. Patrick captured the intimate moment while photographing a troop of some 30 baboons in Zambia's South Luangwa National Park. 'I wanted to capture an image showing the strong social bonds that exist between baboons,' said Patrick, who positioned himself so that their fur was backlit and then underexposed the shot to retain the detail.

Nikon D2X + 200-400mm f4 lens; 1/125 sec at f7.1 (-1 e/v); ISO 200.

Urban and Garden Wildlife

These pictures must show wild plants or animals in an urban or suburban environment, the aim being to show wildlife living in close proximity to human habitation.

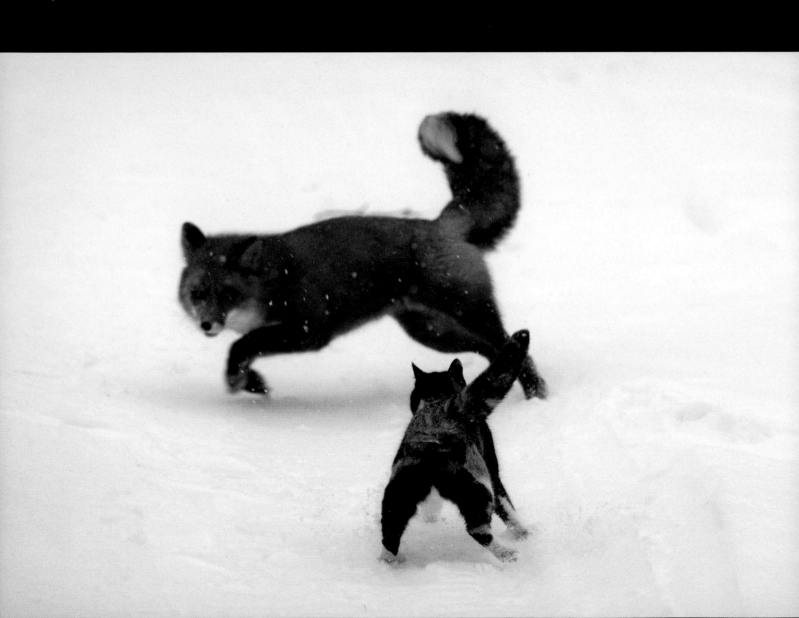

Water fight

HIGHLY COMMENDED
Andrew Forsyth
UNITED KINGDOM

Two young rhesus macaques squabble over a leaking tap on the outskirts of Jaipur city, Rajasthan, India, in blistering 45°C (113°F) heat. Monkeys are an accepted part of city life, their presence tolerated in gratitude for their legendary role in the Hindu god Hanuman's defeat of the demon King Ravana. In the dry season, water resources for the 3 million human inhabitants are stretched to the limit. Though Hindu devotees feed the monkeys regularly, they don't necessarily give them water, and so a dripping tap is a valuable resource. Andrew is doing a long-term photographic study of the macaques and spotted these two youngsters just as one was yanking the other off the tap, hoping for access to a thirst-quenching drip. Both monkeys fell off the tap, but their squabble then turned into exuberant play.

Canon EOS-1D Mark II N + Canon EF 16-35mm f2.8 lens at 35mm; 1/200 sec at f9; ISO 200.

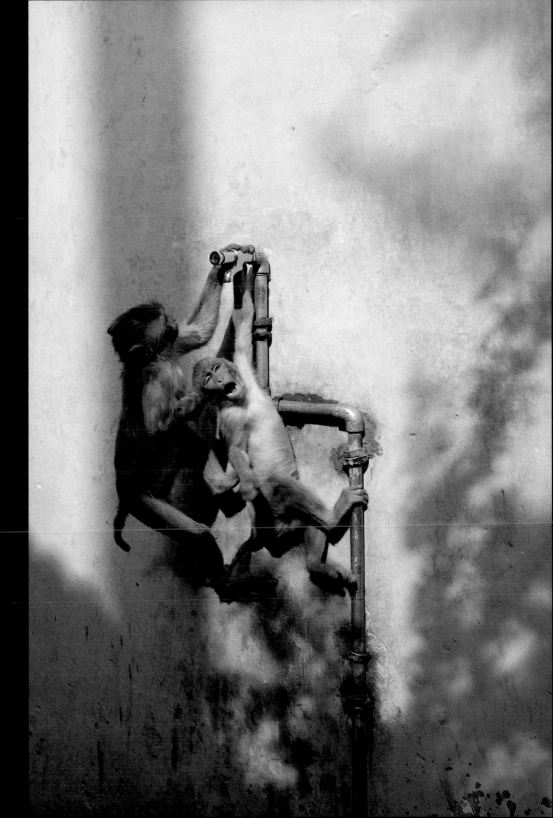

Respect

WINNER
Igor Shpilenok
RUSSIA

In the winter of 2007/08, Igor spent five months as a ranger in the Kronotsky Nature Reserve in Kamchatka in the Russian Far East, taking his cat Ryska with him for company. Immediately, she staked out her territory and set to work showing the local foxes who was boss. Each day, the foxes came looking for food, even peering through the window of Igor's cabin. Ryska was having none of it. With her impressive weaponry of sharp claws and teeth, 'she soon earned respect from them – and from me,' says Igor, 'living up to her name, which means little lynx in Russian.'

Nikon D3 + 300mm lens; 1/500 sec at f4.5; ISO 640.

In Praise of Plants

The aim of this category is to showcase the beauty and importance of flowering and non-flowering plants and fungi, whether by featuring them in close-up or as part of their environment.

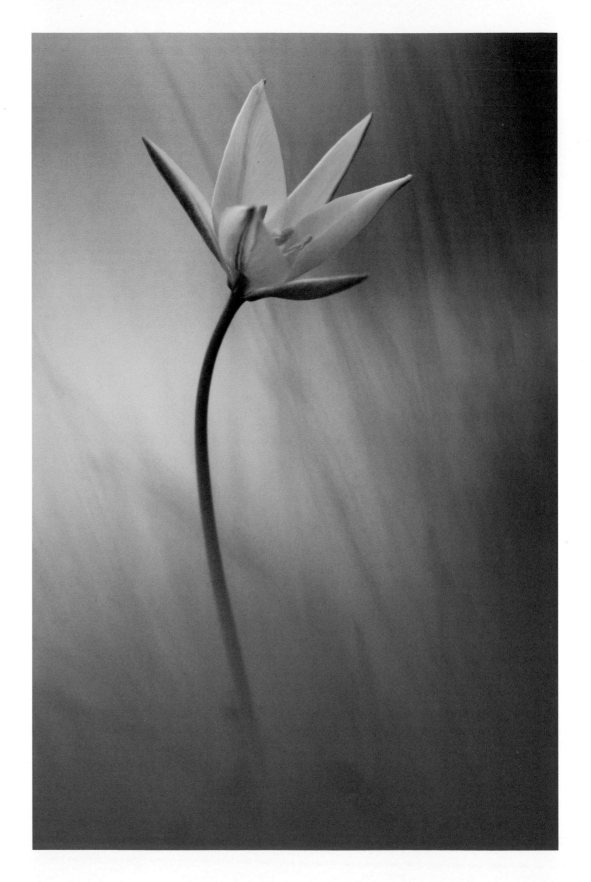

Sun-touched tulip

RUNNER-UP

Serge Tollari

FRANCE

Serge noticed this delicate flower during a walk along a lane in Hérault, southern France. He knew it to be a subspecies of the wild tulip *Tulipa sylvestris*, distinguished by the scarlet tint on the back of the petals. The background was full of distracting elements, but Serge isolated the tulip in the frame, setting it against gentle colour through close focusing. 'The yellow is a sunny meadow in the background, the green is from grass in the foreground, and the blue is the lane in shadow.'

Canon EOS 400D + Canon 300mm f4L IS USM lens; 1/350 sec at f4; ISO 200.

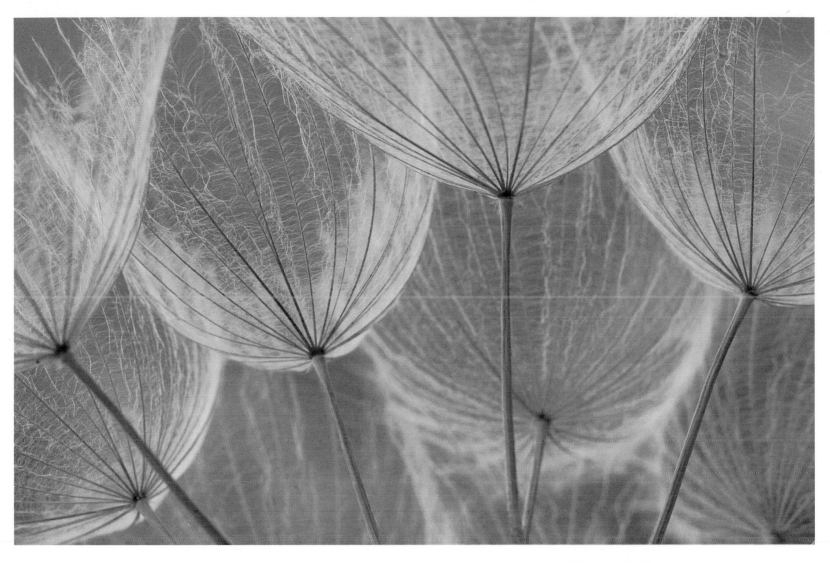

The salsify canopy

WINNER

Ana Retamero

SPAIN

Walking through a meadow near Jerez de la Frontera, southern Spain, Ana came across the distinctive seed-head of a salsify. She realized that a close shot of the delicate 'umbrellas' would restrict the depth of field, while depth of field would make the image too busy. 'So I imagined what it would look like from an insect's perspective, walking through those silky seeds' and photographed it from a low angle using an intermediate aperture to create a feel of a miniature forest canopy.

Nikon D70s + Nikkor 105mm f2.8 lens; 1/40 sec at f14; ISO 200.

Beach-grass sandscape

HIGHLY COMMENDED

Mariusz Oszustowicz

POLAND

The storm that hit the coastal dunes of Poland's Slovinski National Park had been so strong that Mariusz had had difficulty just standing up, and his camera had filled with sand. Walking through the moonscape of the now-still dunes, Mariusz came across a magical valley. The marram grass had been buried by sand and sprinkled with frost, the texture and colours enhanced by an overcast sky, creating an unforgettable scene.

Olympus OM-4Ti + Olympus Zuiko 100mm f2.8 lens; 1/60 sec at f5.6; Fujichrome Velvia 50; Manfrotto 441 tripod.

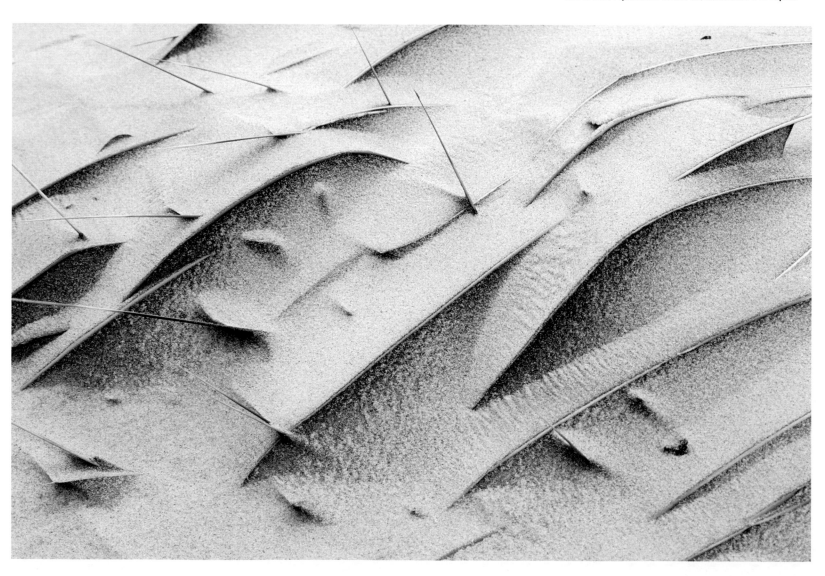

Wild spring garden

HIGHLY COMMENDED

Floris van Breugel

USA

Floris spent many early spring mornings walking through his local woods in Ithaca, New York, on the lookout for birds to photograph. But his prize discovery was this miniature spring glade with an azalea in bud, unfurling ferns and verdant mosses. 'It took me several days,' says Floris, 'knee-deep in swamp before I settled for this angle.' After establishing the composition, he then waited for the azalea flowers to open fully. As he set up his equipment early one May morning, a sprinkle of rain added the final magic touch.

Canon EOS-5D + Canon EF17-40mm f4L USM lens; 1/4 sec at f16; ISO 200; polarizer; Feisol tripod + Markins M20 Ball Head.

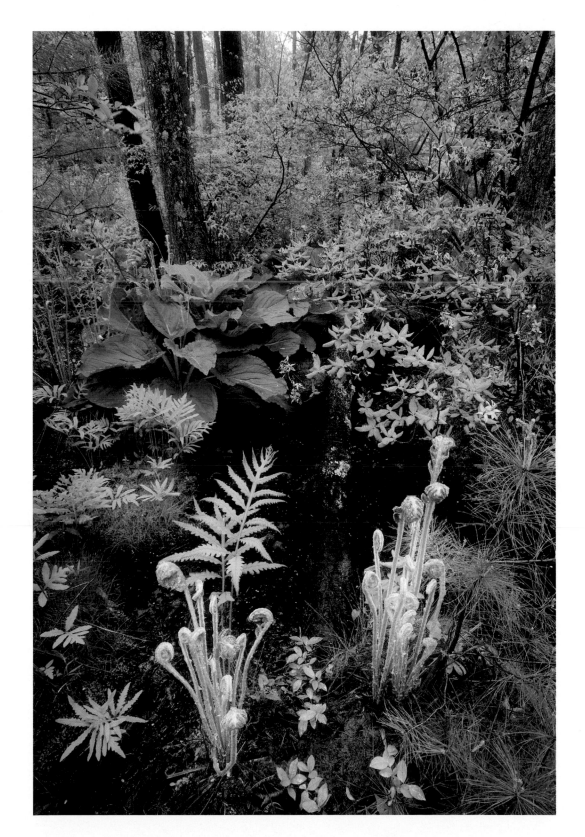

Animal
Portraits

This category – one of the most popular in the competition – invites portraits that capture the character or spirit of an animal in an original and memorable way.

The storybook wolf

WINNER
José Luis Rodríguez

SPAIN

When José Luis realized he had got the shot of his dreams – one that he had even sketched on paper – he couldn't quite believe it. From the start, his fear had been that the wolves would be too wary. Iberian wolves have always been persecuted by people who see them as a threat to game and livestock (which they hunt when natural food is scarce) but also because of ignorance and superstition about the supposed danger they pose. Even though they have always lived close to humans, there are no verified incidences of them attacking people. In Spain, the population of Iberian wolves – a subspecies of the grey wolf – is thought to number 1000-2000 in the north, with a few tiny, isolated populations in the south.

José Luis risked a slow shutter-speed to reveal the moonlit sky and conjure up the atmosphere of the place. He switched from using his Nikon D2X to a Hasselblad so he could get the exact framing that he had in mind. What José Luis hopes is that his picture, 'showing the wolf's great agility and strength', will become an image that can be used to show just how beautiful the Iberian wolf is and how the Spanish can be proud to have such an emblematic animal. (See also page 14.)

Hasselblad 503CW with a 6x6 Fujichrome backing + Planar 80mm lens; 1/30 sec at f11; ISO 50; purpose-made Ficap infrared camera trap.

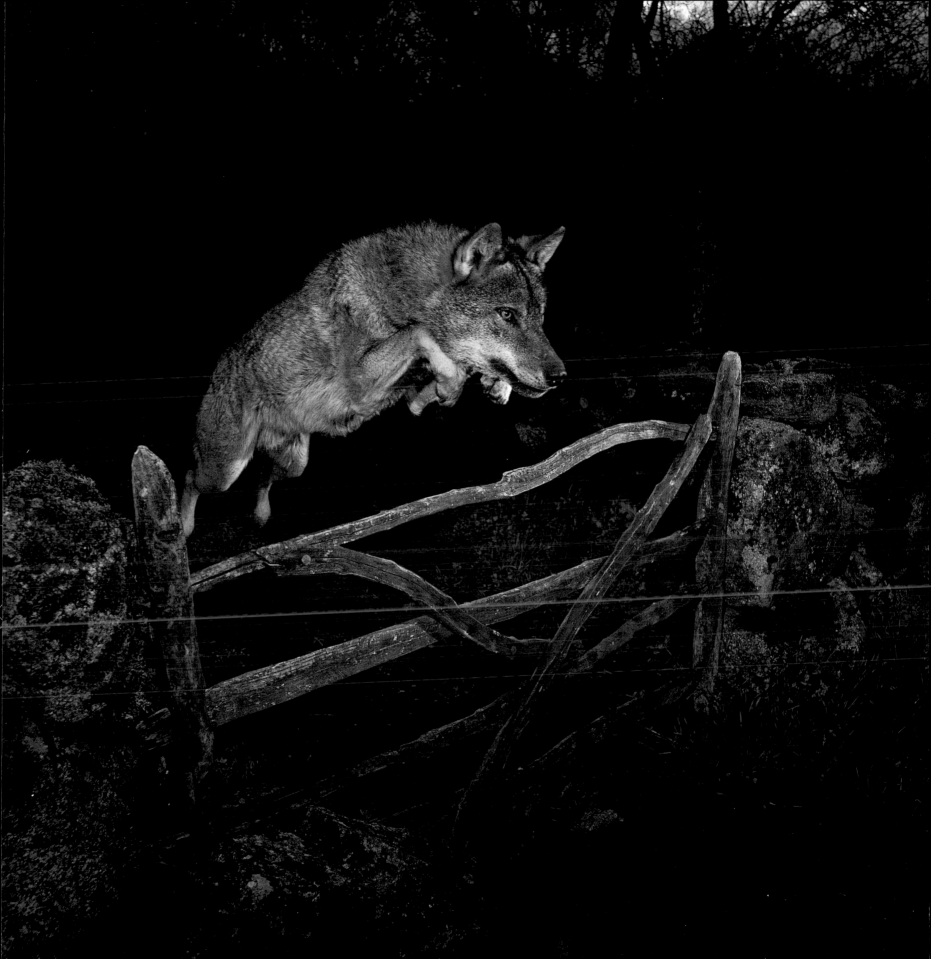

The full lion

RUNNER-UP

Marc Slootmaekers

BELGIUM

Every time the lions moved the carcass, a stench of death emanated from under the bushes where the two were feasting. Their breakfast in Kenya's Masai Mara was a buffalo they had killed in the night. When he was full, one male moved out of the shade and onto a termite mound, 'so close that I could hear the flies buzzing around his head', says Marc, who had arrived at the spot just as the sun rose, to make the most of the soft, early-morning light. The lion stretched and rolled over, exposing his taut belly. 'Then, totally relaxed, he turned and stared straight at me,' with the penetrating look of a supreme predator.

Canon EOS 40D + 100-400mm f5.6 lens at 350mm; 1/700 sec at f6.7; ISO 200; beanbag.

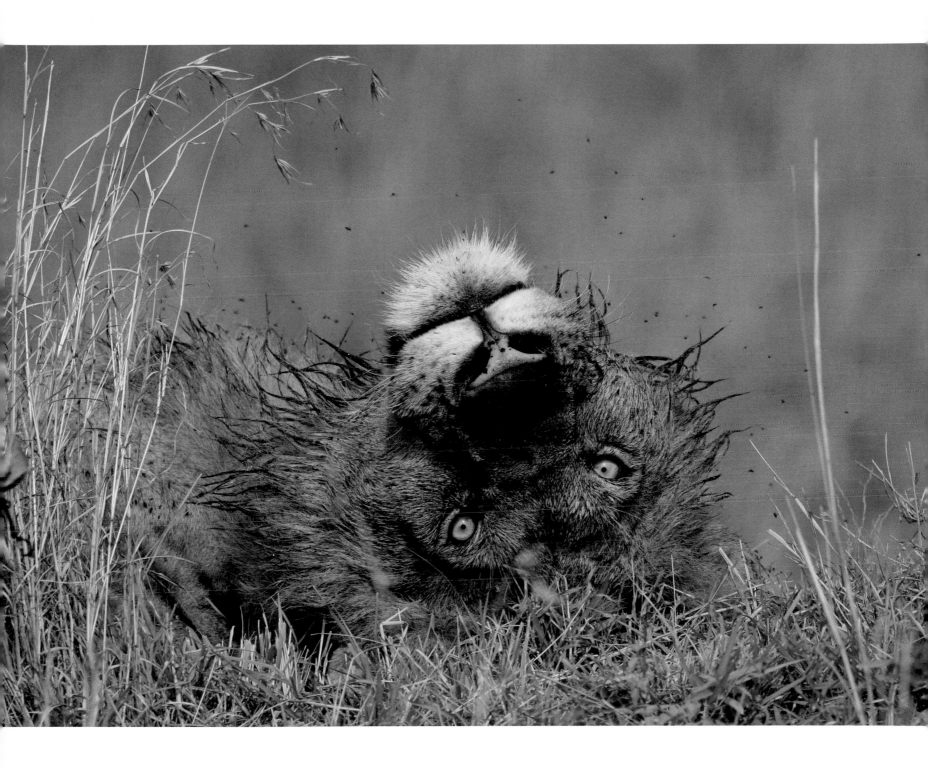

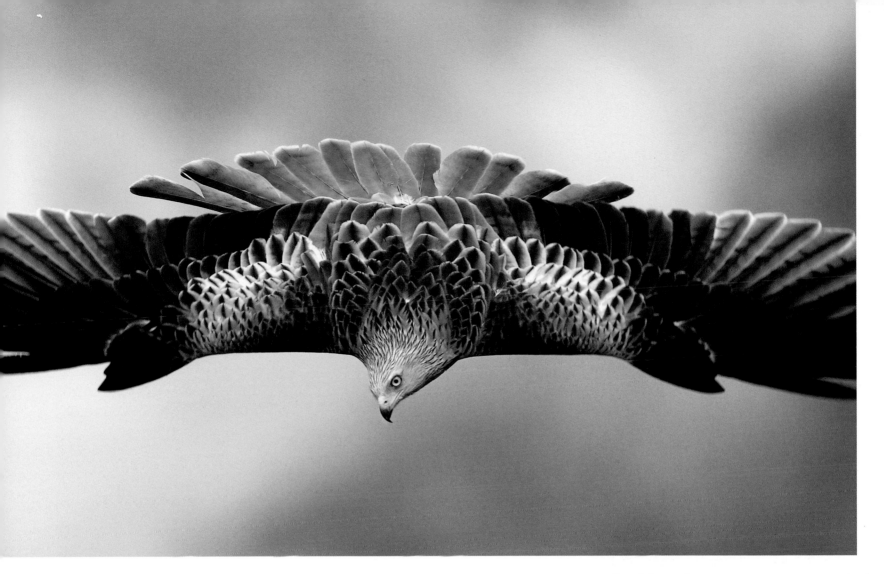

Ethiopian mountain king

RUNNER-UP

Joe McDonald

USA

Hairstyle and looks are part of a male gelada's repertoire – the more magnificent the mane, the more impressive the male. His huge canines are weapons of threat (geladas eat grass), and part of everyday messaging are a range of expressions involving eyebrow-raising, eyelid-flashing, mouth-opening and lip-curling. Posing on a cliff edge high up in Ethiopia's Simien Mountains (geladas are found only in Ethiopia), he and the rest of the band are about to retire to their sleeping ledges. In the evening light, his mane appears like a golden shawl. 'He was compellingly, strikingly beautiful,' says Joe.

Canon EOS-1D Mark III + 500mm lens; 1/200 sec at f4; ISO 640.

Red kite hover

SPECIALLY COMMENDED

Javi Montes

SPAIN

For several years, Javi has been photographing scavenging birds in the Pyrenees, learning much about their hunting methods and the order they arrive at carrion. Here, at El Pont de Suert, in Lérida, Spain, he focused on the red kites. Once food has been spotted, the kite hovers, waiting for the right moment 'to launch into a spiral down to its target, using the element of surprise to snatch a beakful and even stealing food off other birds.' After days in his hide, Javi finally got the portrait he was after, capturing 'the beauty of the kite's plumage, the way he manoeuvres and the concentration of his look.'

Canon EOS-1D Mark III + Canon 300mm f2.8 lens; 1/800 sec at f3.5; ISO 500.

Social river Amazons

SPECIALLY COMMENDED

Kevin Schafer

USA

Midday was the best time for photographing
the river dolphins (botos) in the murky water of
the Rio Negro, Brazil. 'Unlike other dolphins, which
have fused vertebrae,' says Kevin, 'botos are very
flexible,' as evidenced by this individual turning to
look at him. Kevin spent weeks in the water with
the dolphins and found them playful, social – and
very strong. 'One accidentally thrashed me as it
passed by and shattered my underwater housing,'
Kevin adds. 'But not before I got this shot.'

**Nikon D200 + Nikkor 12-24mm DX lens; 1/160 sec at f4;
ISO 320; Sea & Sea DX-D200 housing.**

Water-scoop

SPECIALLY COMMENDED

Jérôme Guillaumot

FRANCE

For a full hour, Jerome was treated to a territorial display of head-shaking, lunging and splashing, with attendant groans, grunts and grumbles. The male hippopotamus was claiming supremacy over a group of opponents at a waterhole in Tanzania's Serengeti. He would dive below the surface, explode out again and crash down in a spectacular belly-flop. Here he ends a yawning display with a powerful water-scoop.

Nikon D300 + AF-S Nikkor 300mm lens; 1/4000 sec at f2.8; ISO 400.

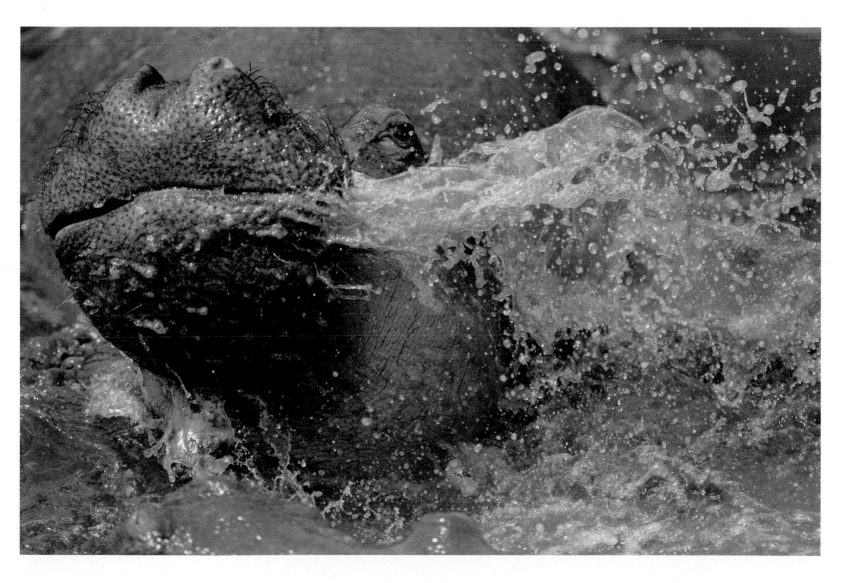

Eyes in the oasis

HIGHLY COMMENDED
Lee Slabber
SOUTH AFRICA

Every morning, Lee would drive 50 kilometres
(32 miles) across the Kalahari Desert dunes that
separated two dry riverbeds in the Kgalagadi
Transfrontier Park, South Africa. The only sign
of life – or rather, death – was near a small pan,
a mini-oasis in the middle of the dunes, where
oryx bones lay scattered all about in various states
of decay. One day, Lee stopped to photograph the
bones. As he did so, he sensed that he wasn't alone.
'I got the feeling I was being watched,' he said.
'I slowly turned to face a most beautiful young
male leopard, looking intently at me from behind
a small bush. I could see how the deep-red dunes
would be perfect camouflage for him.' A moment
later, the leopard fled, 'obviously as shocked to
see me as I was to see him.'

Canon EOS-1D Mark III + Canon EF 600mm lens; 1/250
sec at f5.7; ISO 200.

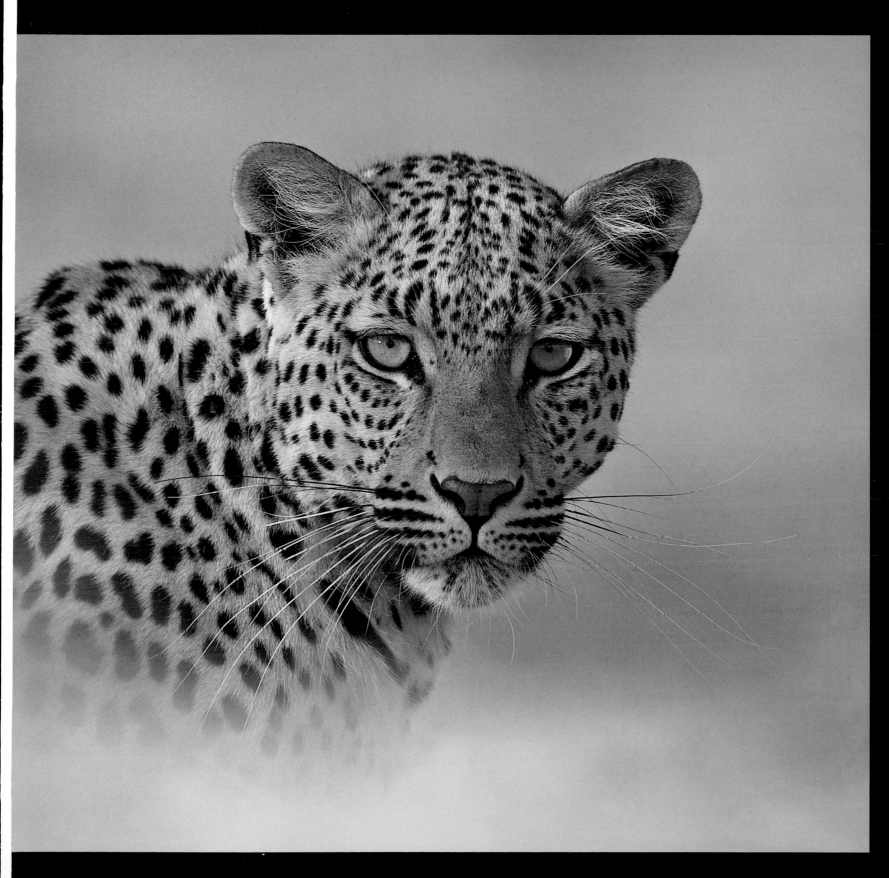

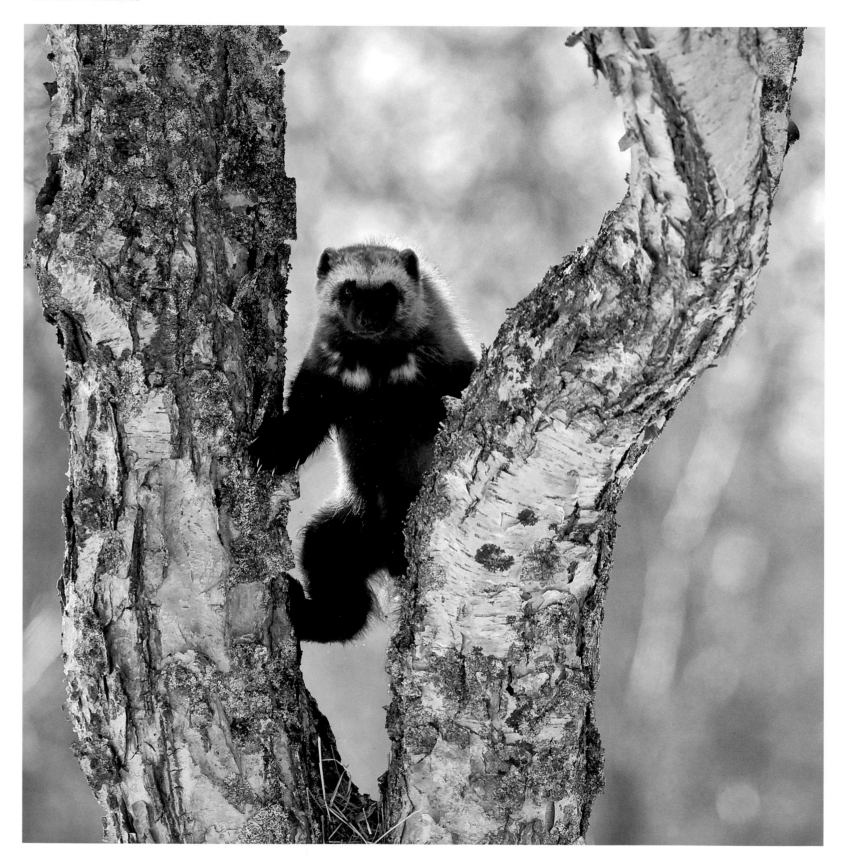

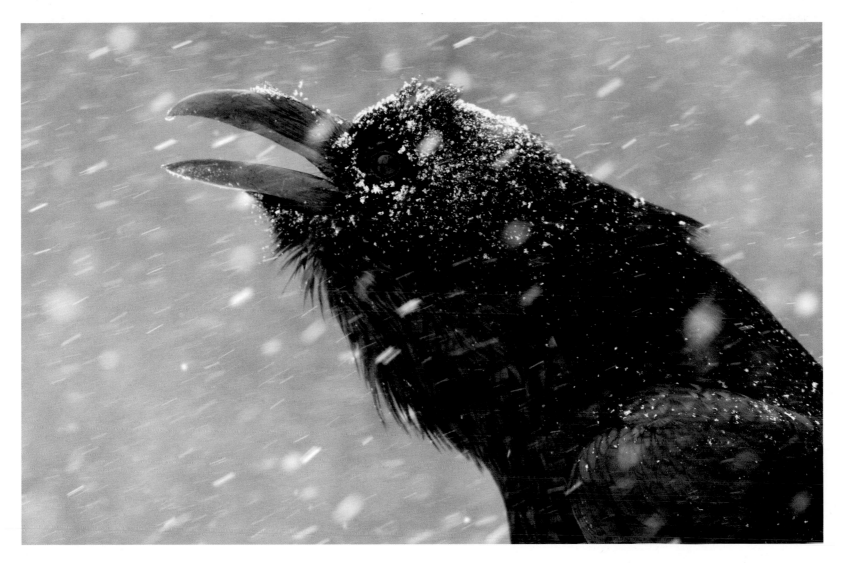

Wild, wild wolverine

HIGHLY COMMENDED

Sergey Gorshkov

RUSSIA

Fleeting glimpses and tracks were all that Sergey had ever seen of wolverines during the six years that he worked in Russia's Kamchatka Peninsula – that is, until five wolverines turned up close to his house. They arrived to feast on the carcass of a bear that had not survived the winter. 'At night, they climbed over my cabin and chewed my tripod and all the rubber off my snowmobile.' Two days later, the carcass had been picked clean and the wolverines had vanished. 'I'm certain I will never see so many in one place ever again,' says Sergey.

Nikon D3 + Nikkor 600mm lens; 1/640 sec at f4.5; ISO 200.

Call of the raven

HIGHLY COMMENDED

Jarmo Manninen

FINLAND

It was ten years ago that Jarmo first began tempting ravens to his hide, set up close to where he lives in Kangasniemi, Finland. At first, the ravens were very wary – at the slightest sound, they would fly off – but they grew used to the hide and its clicking noises and now take no notice of Jarmo's arrival. In early spring, while it is still bitterly cold, the ravens begin their courtship calls and postures. Here a male, paying no attention to the heavy snowfall, is trying its hardest to get the attention of a female.

Canon EOS-1D Mark III + Canon EF 300 f2.8L IS USM lens + 2x converter; 1/250 sec at f5.6; ISO 800.

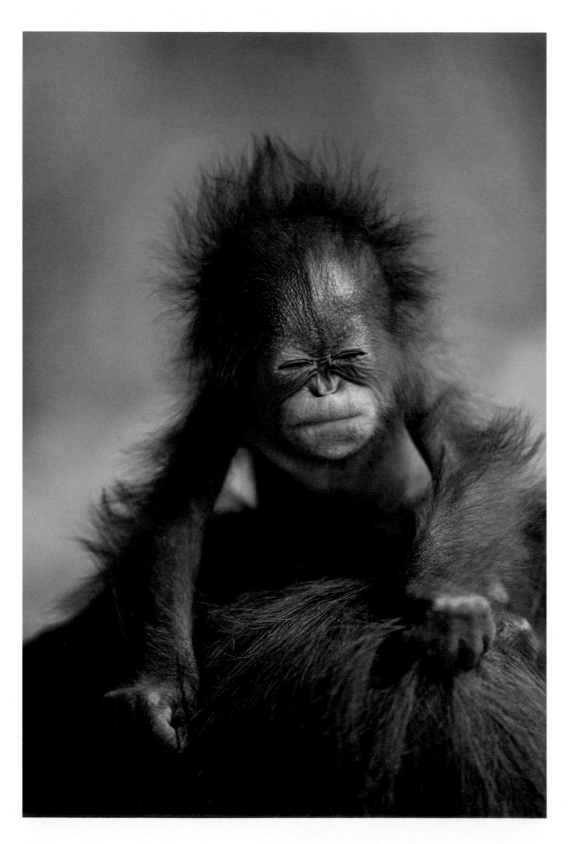

Borneo baby

HIGHLY COMMENDED

Brian Matthews

UNITED KINGDOM

The baby could have been only a couple of months old, but its mother was used to the orangutan researchers and was comfortable for them to watch her from about 5 metres (16 feet) away. Brian was working with the researchers in Tanjung Putting National Park, Kalimantan (Indonesian Borneo), photographing wild orangutans in the rainforest. When the infant stuck its tongue out, scrunched up its face and blinked, 'it was impossible not to be reminded of a human baby.' In fact, orangutans have the longest child-rearing period of any non-human mammal, and this baby will remain with its mother for up to nine years, learning the ways of the forest from her.

Canon EOS-1Ds Mark II + Canon 300mm f2.8L USM IS lens; 1/250 sec at f2.8 (-1 1/3 e/v); ISO 200; fill-flash.

Hare sitting tight

HIGHLY COMMENDED

Klaus Tamm

GERMANY

In early March, Klaus and his 14-year-old son Paul set out to photograph frogs near their home in Wuppertal, Germany. On the way, Paul suddenly stopped and gestured to his father to look to the side of the path. It took a minute or so for Klaus to see the hare crouching just 8 metres (26 feet) away, camouflaged in the grass. 'It didn't move a whisker,' he said, as he and Paul took photographs. The hare was still in the same position when they walked back home again. Klaus was thrilled with the encounter, as hares are no longer common where he lives. 'A decade ago,' he says, 'I would see up to ten hares on a morning walk like that.'

Canon EOS-1D Mark III + 600mm f4 lens + EF 2x II extender; 1/125 sec at f9; ISO 500.

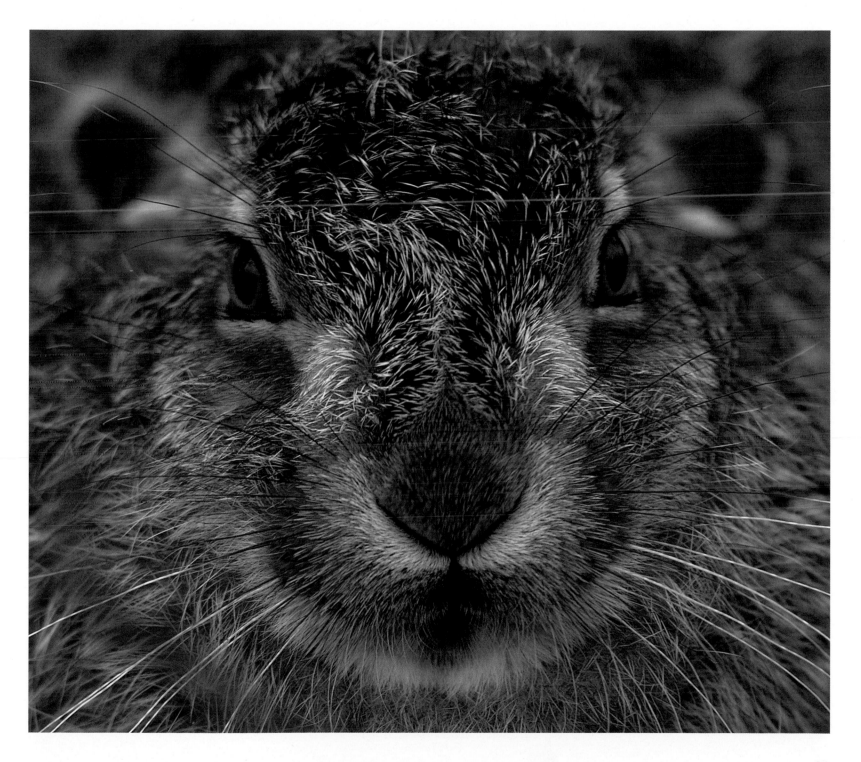

Wild Places

This is a category for landscape photographs, but ones that must convey a true feeling of wildness and create a sense of awe.

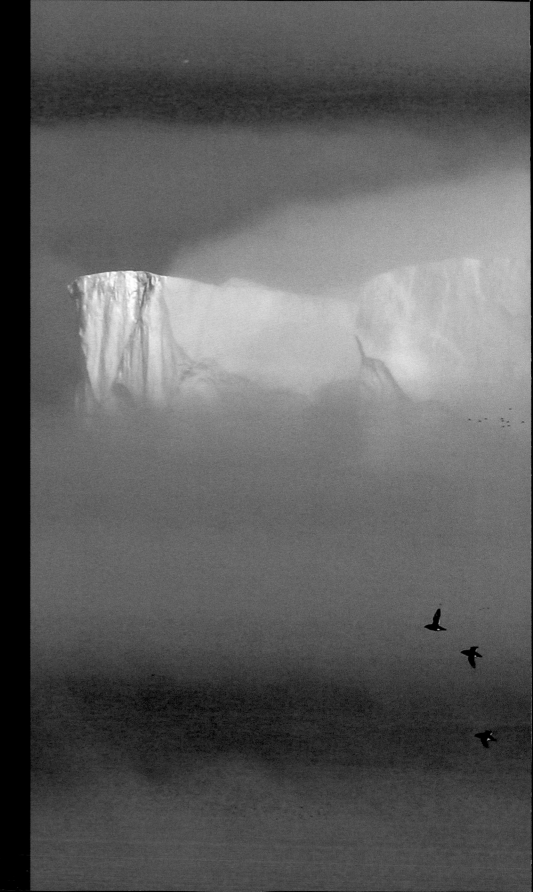

Big fjord, little auks

WINNER

Carsten Egevang

DENMARK

Carsten spent a month doing tent-based summer fieldwork on Arctic seabirds at the world's longest fjord, Scoresbysund Fjord, in northeast Greenland. It was a remote, desolate, spectacular wilderness. Every day, watching from a clifftop, he was treated to a magnificent spectacle: millions of little auks flying between their summer breeding colonies and their feeding grounds out at sea. 'At times, the air was full of their calls,' he says. 'It's a sound that, for me, truly captures the sense of the Arctic.' On this day, a cold fog rolled in from the sea and wrapped itself around the massive icebergs stranded at the mouth of the fjord.

Canon EOS 10D + 100-400mm f4.5-5.6 lens; 1/1000sec at f9.5; ISO 200.

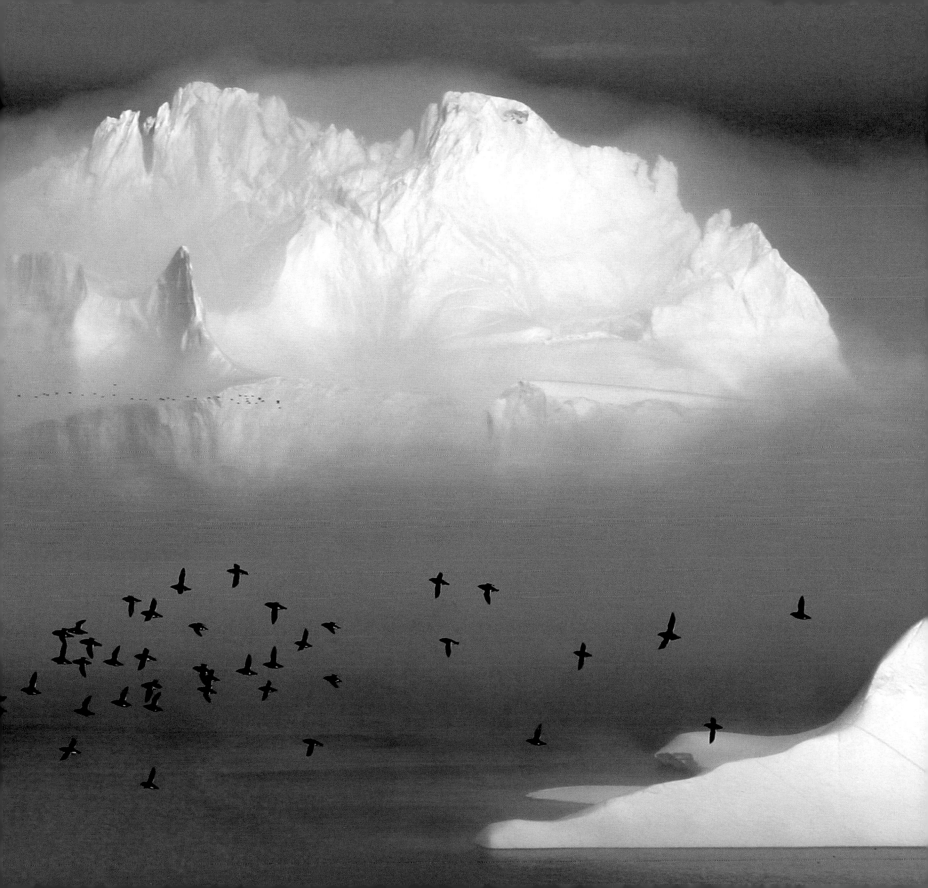

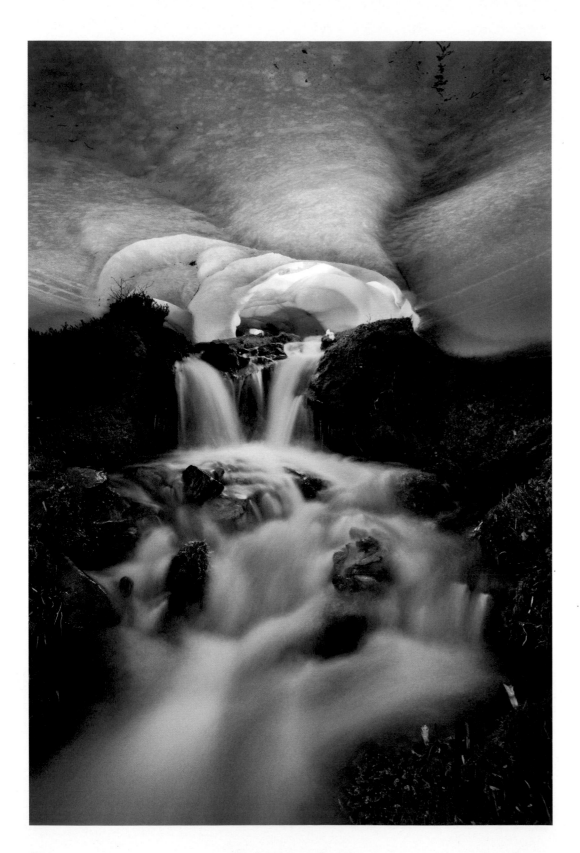

The fountain of ice

HIGHLY COMMENDED

Floris van Breugel

USA

The Bailey Range in Olympic National Park, Washington, is a challenging route with few trails. Scrambling and rock-climbing with a heavy pack, Floris was forced to stop short of his destination. But that didn't matter, because close to where he camped, he discovered this miniature gem of an ice-cave and waterfall. The ice had melted to the thickness that allowed just the right amount of light to filter through and produce an otherworldly blue, illuminating the waterfall and waterside plants.

Canon EOS-5D + Canon EF 17-40mm f4L USM lens; 2 sec at f16; ISO 400; Feisol tripod + Markins M20 Ball Head.

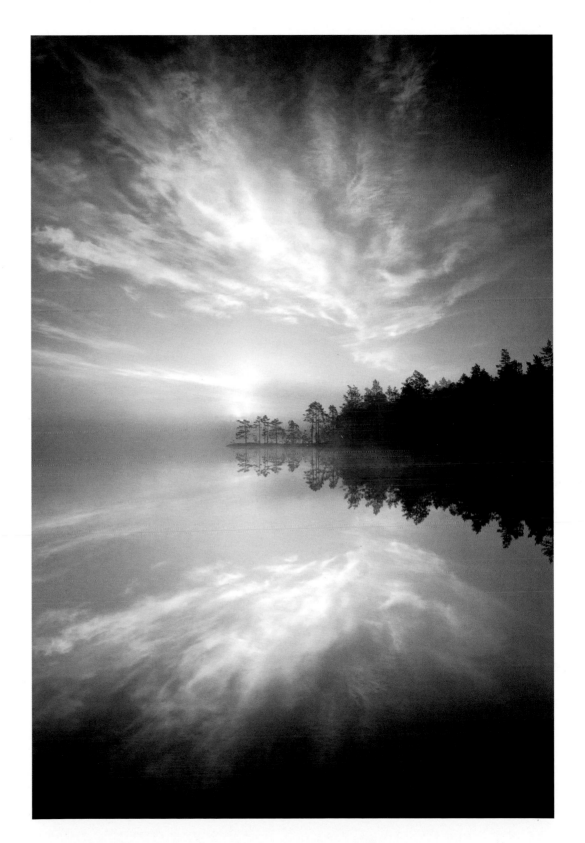

Magical morning

Magnus Lindbom

SWEDEN

'I woke up in my tent very early on a spring morning in Tyresta National Park, just south of Stockholm. The lake was still as a mirror and fog had rolled in during the night. This was one of those mornings you long for. I really enjoy working with reflections, and when I saw the cloud formation, I knew the image I wanted to make. The sun breaking softly through the fog was the bonus. It was amazing to witness a wild scene like this so close to a city.'

Canon EOS-5D + Canon EF 17-40mm f4L USM lens; 1/8 sec at f11; ISO 100; Feisol tripod + Acratech Ultimate ballhead.

The great California flowering

HIGHLY COMMENDED

Rob Badger

USA

Only an hour's drive from Los Angeles is the Tejon Ranch Preserve – a newly created refuge for the wild flowers that would have once been a common sight in southern California. But a spectacular flowering happens there rarely. In fact, Rob had waited 40 years for the perfect event. The floral explosion depends on the rains, and when, in April, Rob heard that the weather he had been tracking since November had finally created an explosion of wildflowers, painting the normally brown hillsides with splashes of brilliant colour, he set off to the huge ranch. For a few days he travelled the hills, looking for the best vantage point that would convey the immense scale of the flowering in this magical place – famous throught the American West. In a fleeting moment, everything came together: while fog muted the colours on the slope behind, sunlight penetrating through holes in the fast-moving, dark clouds illuminated the field of flowers in front, displaying at its best an immense floral tapestry of colours not seen in more than half a century.

Hasselblad 553 ELX + Zeiss 500mm lens; B+W warming polarizing filter; 1/125 sec at f11; Fujichrome Velvia 100; cable release; Gitzo tripod + Arca Swiss Ball Head.

Animals in Their Environment

A winning photograph must create a sense of place and convey a feeling of the relationship between an animal and where it lives.

Springtail on a snowflake

WINNER

Urmas Tartes

ESTONIA

To the tiny insects that negotiate it every day, snow is an icy range of plunging chasms and jagged cliffs. Peering close, Urmas found springtails (also known as 'snow fleas') clambering over snowflakes near Vilbaste Springs in Estonia. When the temperature drops, many of these two-millimetre-long insects climb down through the frosty crevasses to the soil below. It's a little bit warmer there, thanks to the insulating power of the snow. As it warms up again and the snow starts to thaw, the springtails clamber back up to the surface, perhaps to feed on tiny particles of debris. This day, Urmas was lucky. It was warm enough for the springtails to be active but still cold enough for the snowflakes not to melt.

Canon EOS-5D Mark II + Canon MP-E65 f2.5 1-5x Macro lens; 1/200 sec at f14; ISO 400.

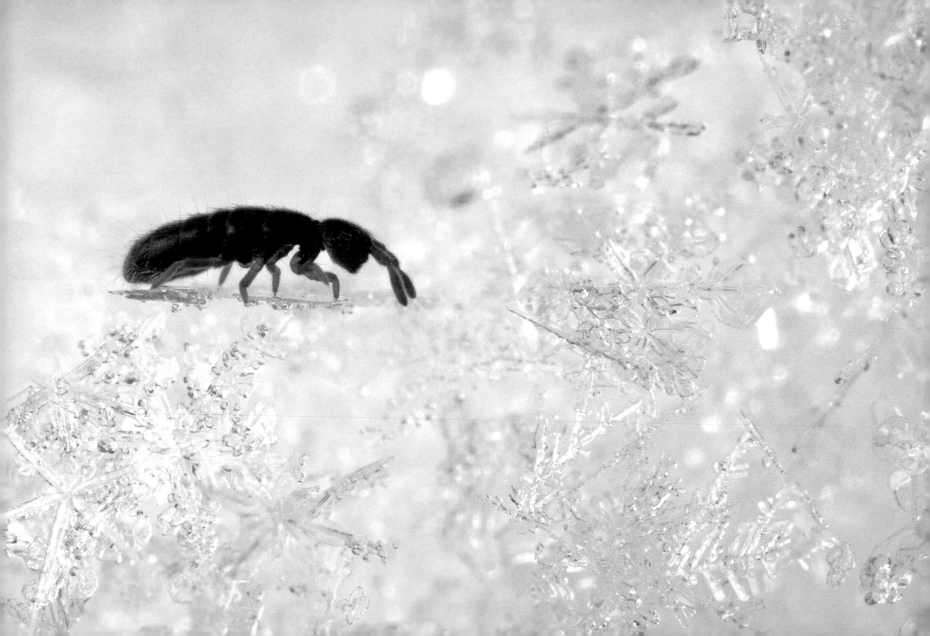

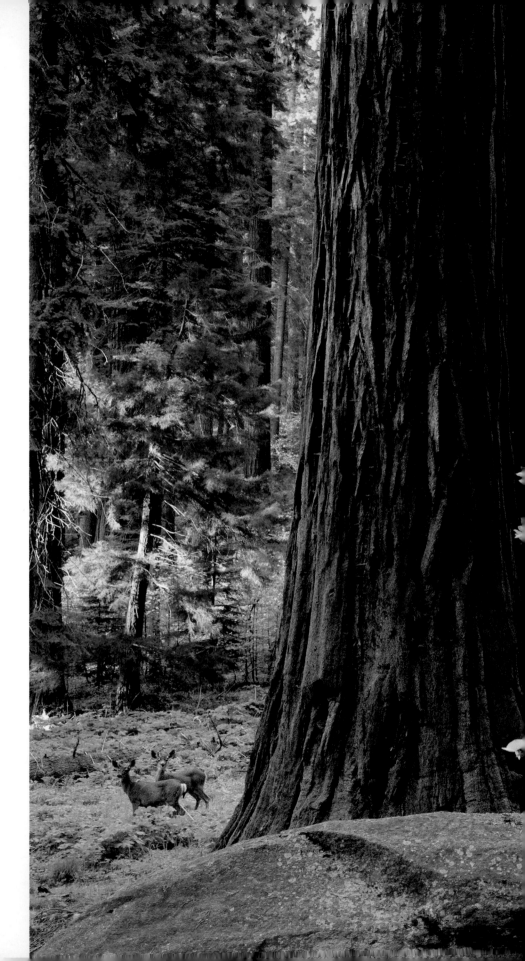

Deer in the grove of giants

RUNNER-UP

Floris van Breugel

USA

Even when it's windy, you don't hear leaves rustling in California's Sequoia National Park. The giant sequoias are simply too tall. They are all trunk for 30 metres (98 feet) or more before there's any foliage at all and can reach a height of 80 metres (262 feet). This grove, flooded with late afternoon light, was as silent as a cathedral – and as magnificent. It was June, and the dogwoods were in full bloom. The sunshine streaming in created a theatrical sense of depth, but it was only when the mule deer wandered into the meadow that Floris was able to capture the scale of the natural architecture, placing them at the edge of the picture so that the viewer would encounter them as a surprise element of the magical scene.

Canon EOS-5D + Canon EF 24-105mm f4L USM lens; 1/3 sec at f16; ISO 800; Feisol tripod + Markins M20 Ball Head.

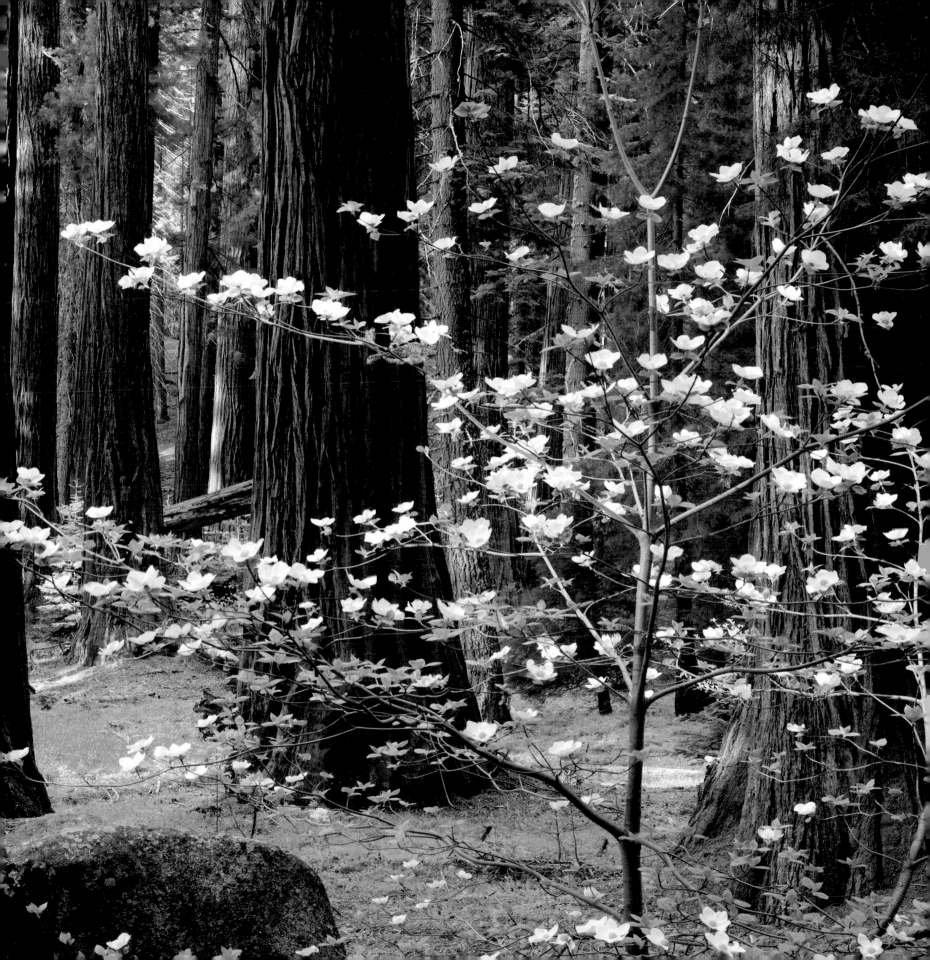

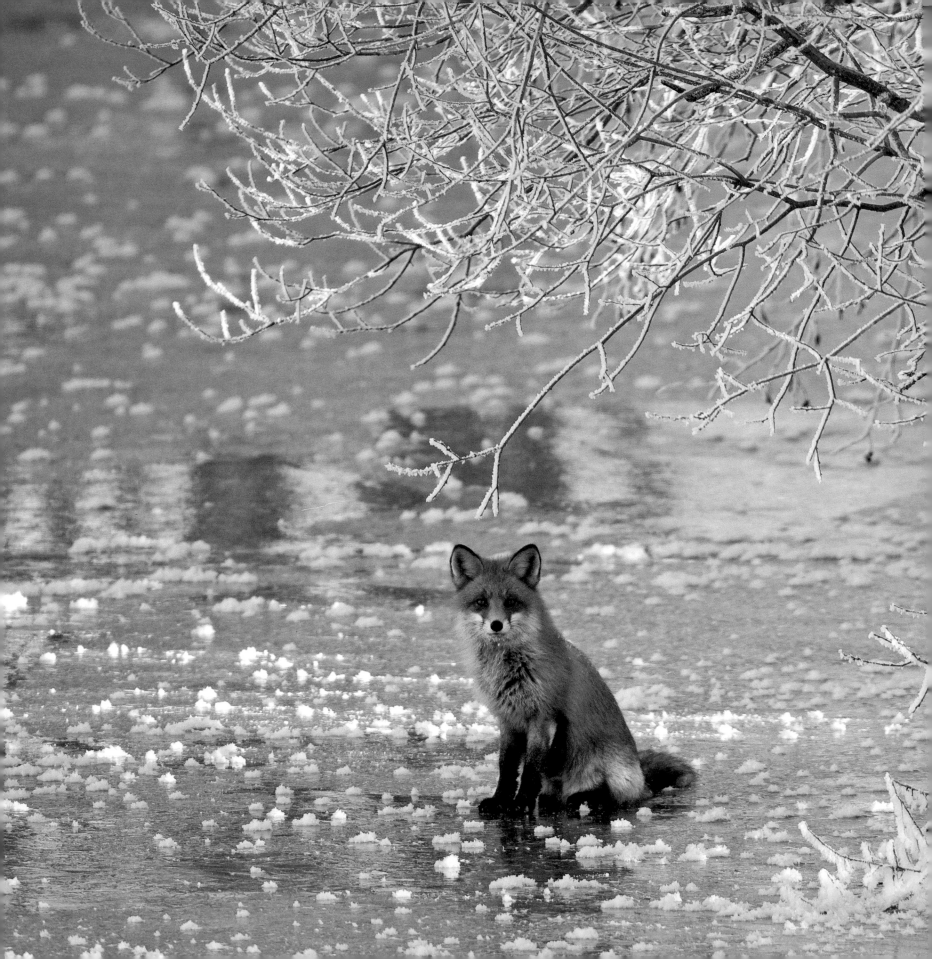

Ice fox

SPECIALLY COMMENDED

Henrik Lund

FINLAND

It was early morning on the last day of January when Henrik set out to photograph dippers. It was exceptionally cold, and the river had frozen. Henrik was expecting to find the dippers fishing in the ice-free rapids close to where he lives in Lappträsk, southern Finland. What he didn't expect was to see a fox sitting on the thin river ice. 'These pearls of wildlife photography often happen when you're actually trying to achieve something else,' Henrik reflects. 'The fox may have been fishing in the rapids, or perhaps he just wanted to enjoy the last moments of warmth from the setting sun.'

Canon EOS-1D Mark III + Canon EF 500mm lens; 1/200 sec at f6.3 (+1.3 e/v); ISO 500.

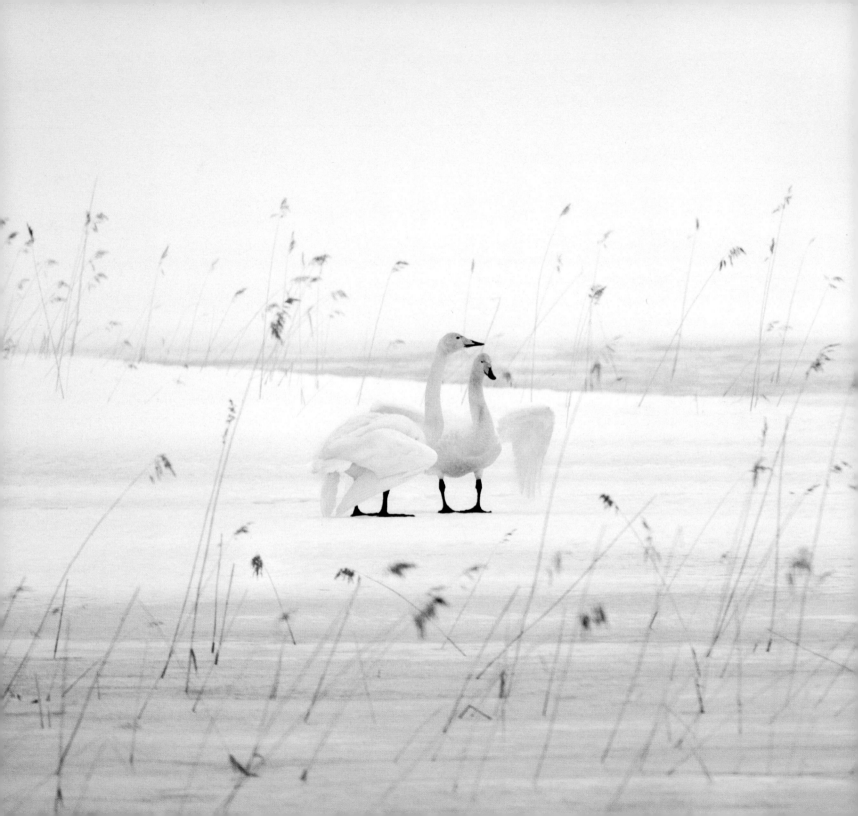

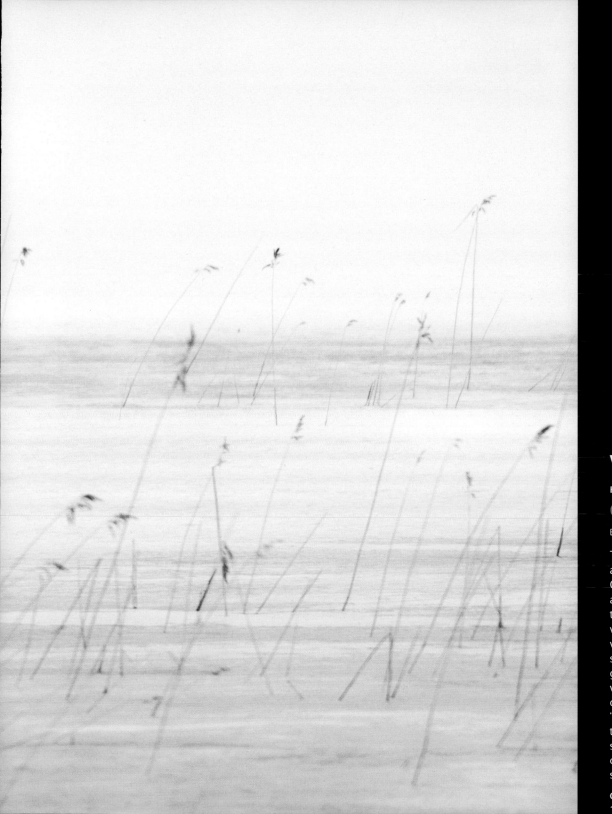

White on white

HIGHLY COMMENDED
Cedric Jacquet
BELGIUM

The frozen lakes near Skellefteå, Sweden,
attract breeding whooper swans each spring.
Cedric searched carefully and finally chose
a slightly elevated vantage point to photograph
the birds against the snow. 'I could shoot them
without disturbing them,' he says, 'with a totally
white background.' This image captures the first
stage in their courtship ritual, when the birds
get close to each other and then wave their
wings slowly up and down. Finally, their wings
outstretched, the birds run after each other.
'I set out to shoot these magnificent birds in
their frozen prenuptial habitat – white on white,'
says Cedric. 'I love how their heads and legs pop
out from the photo, while their plumage blends
so perfectly into the environment.'

**Canon EOS-1D Mark III + Canon 500mm f4 lens;
1/1600 sec, f5.6 (+ 1 e/v); ISO 400; beanbag.**

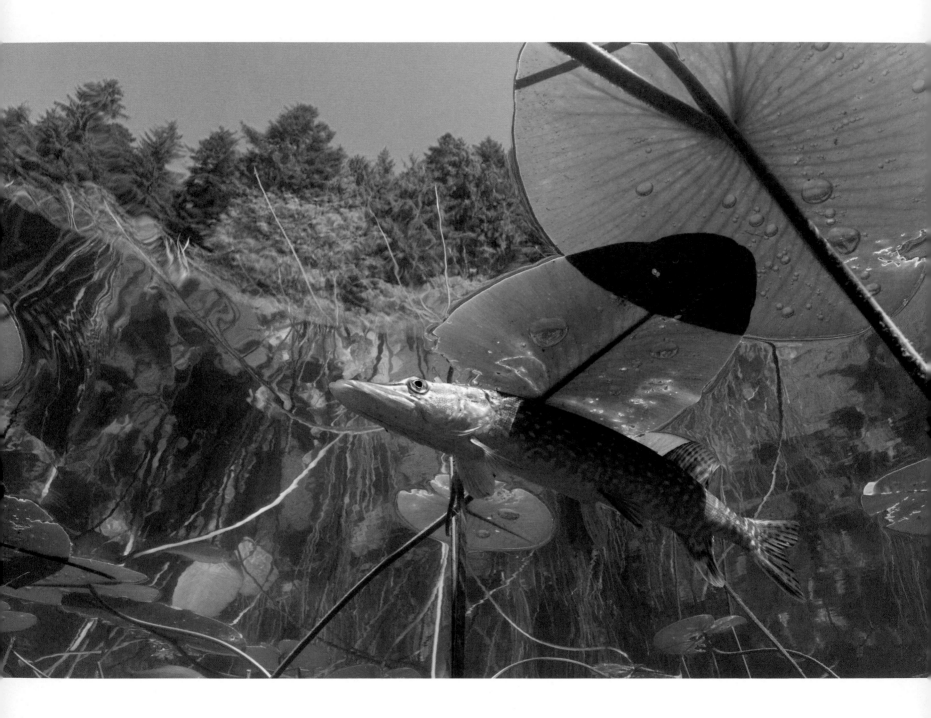

Pike perfection

HIGHLY COMMENDED

Michel Loup

FRANCE

A blue sky, sun filtering down, a pike hanging peacefully beneath water lilies, a glimpse of trees on the lakeshore – the perfect summer scene. Michel set out to create this composition, 'avoiding the photographic cliché of a half-air, half-water shot'. But going from theory to reality was a huge learning curve. He had countless unsuccessful attempts before being able to master this low-angle image. 'But thanks to digital technology,' he says, 'I developed the right reflexes and was prepared when everything came together' – beautiful lighting, gin-clear water, a smooth surface, the perfect foreground and background and, of course, an obliging pike.

Nikon D2X + Nikkor 17-55mm f2.8 lens at 17mm; 1/160 sec at f10; ISO 400; Aquatica housing.

Black bear, ancient redwood

HIGHLY COMMENDED

Michael Nichols

USA

The focus of this picture is not just the beautiful male black bear, it's also the giant chunk of ancient redwood tree behind it – and the story that links the two of them. Felled decades ago, the tree is a thousand years old, perhaps older. Heavy clear-cutting (here in California) since the nineteenth century let in the light and space for fresh undergrowth, rich in berries and young plants. The black bears moved in, tempted by the sweet bark of the tender redwood saplings. The killing of the young trees infuriates the timber companies, who are busy gathering evidence about the black bear population by trapping and radio-collaring bears. A sustainable solution must be found if logging and black bears are to coexist in the vast redwood forests. If it can't be, the next chapter of the story may be the acceleration of legal hunting. There's a twist, too: by defending their territories, male bears may in fact keep the population dispersed and help minimize the killing of the young trees.

Canon EOS-1Ds Mark II; 1/4 sec at f5.6; ISO 125; custom-made camera trap.

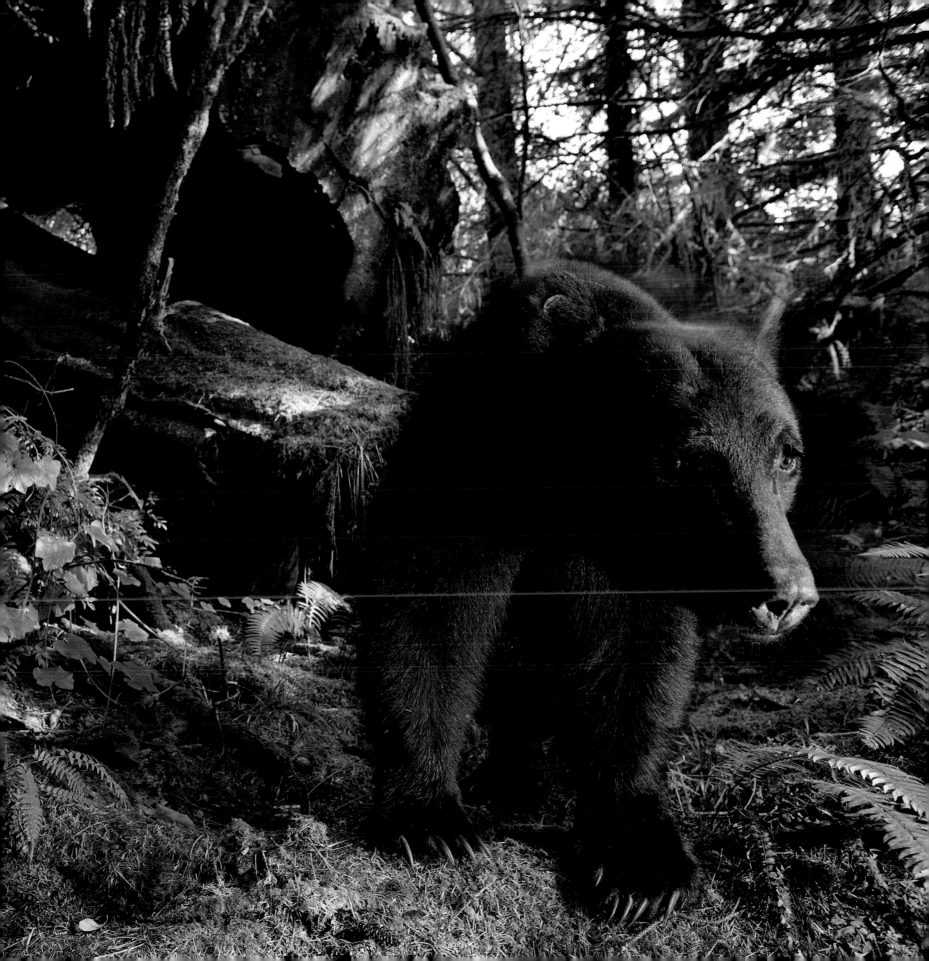

Killer in the mist

HIGHLY COMMENDED

Stefano Unterthiner

ITALY

The picture was taken in a torrential rainstorm
on Possession Island in the sub-Antarctic Crozet
Archipelago. A killer whale family was hunting
king penguins and southern elephant seals just off
a nearby beach. 'Over four months, this was the
first time,' says Stefano, 'that I saw killer whales
so close to shore or to the king penguin rookery.'
The penguins were in a terrible panic, he says.
'The drama was intense, what with the enormous
male, its dorsal fin slicing through the grey water,
and the simply terrible weather.' Stefano spotted
the killer whales from the cliff overlooking the
beach and then spent more than three hours
photographing them in whipping rain. 'It's one of
the most unforgettable moments of my life.'

**Nikon D2X + Nikon 70-200mm lens; 1/500 sec at f7.1;
ISO 250.**

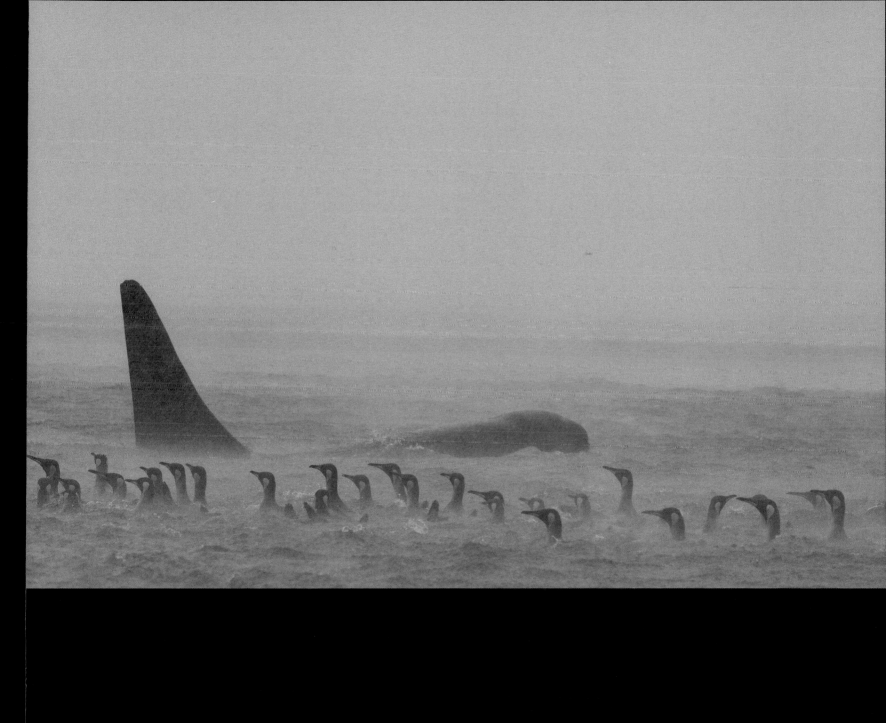

The Underwater World

The subjects in this category can be marine or freshwater species, but must be featured under the water. The pictures must also be memorable, either because of the behaviour displayed or because of their aesthetic appeal – and ideally, both.

Pike reflection

WINNER

Michel Loup

FRANCE

On that summer morning in the Jura Mountains, the lake was both crystal clear and mirror smooth. Michel glided very slowly beneath the surface towards the four pike. 'I was touched by the utter serenity of the scene,' says Michel, 'and the perfect reflections of the fish, intersected by the lines of pondweed.' Trying not to make ripples or bubbles, he stopped breathing and pressed the shutter. 'The yellow pike in the foreground didn't show any sign of nervousness about how close I was, which reassures me that my way of approaching, like a big fish, nonchalant and feigning indifference, didn't disturb him.' The pike, too, was practising the same technique, stealthily moving closer to fish prey.

Nikon D2X + Sigma 10-20mm f4-5.6 EX DC HSM lens at 20mm; 1/80 sec at f10; ISO 400; Aquatica housing.

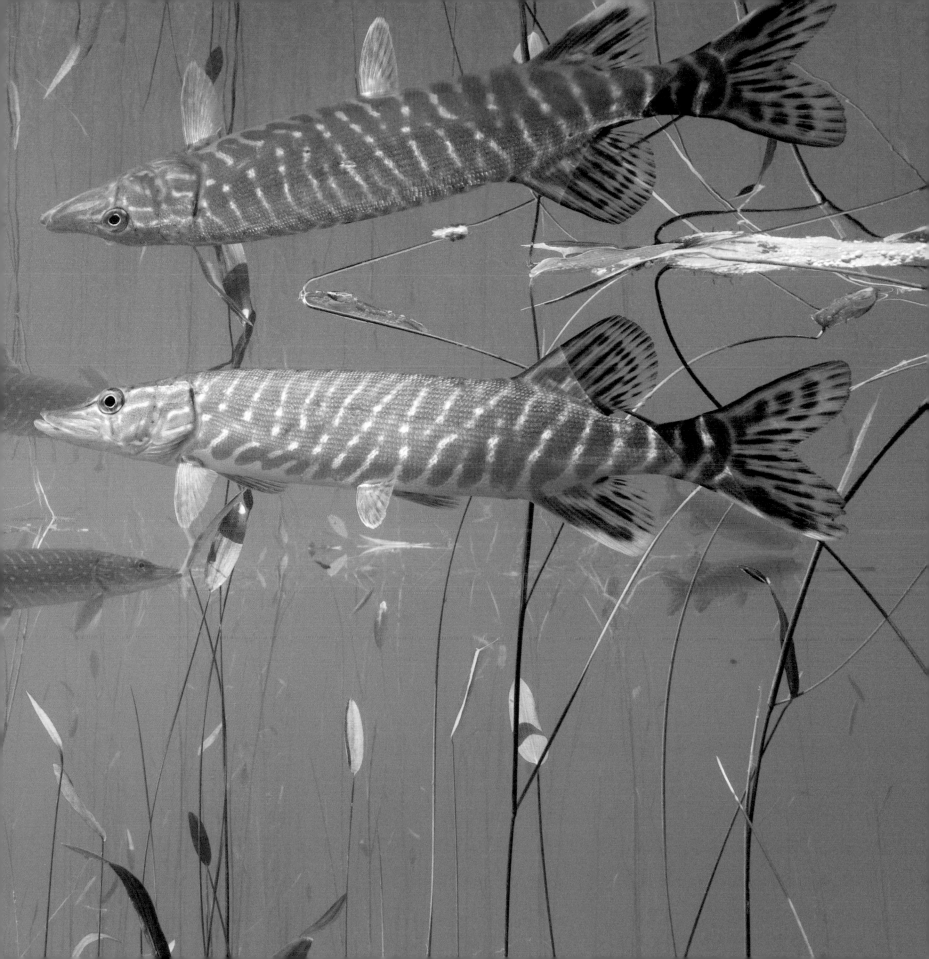

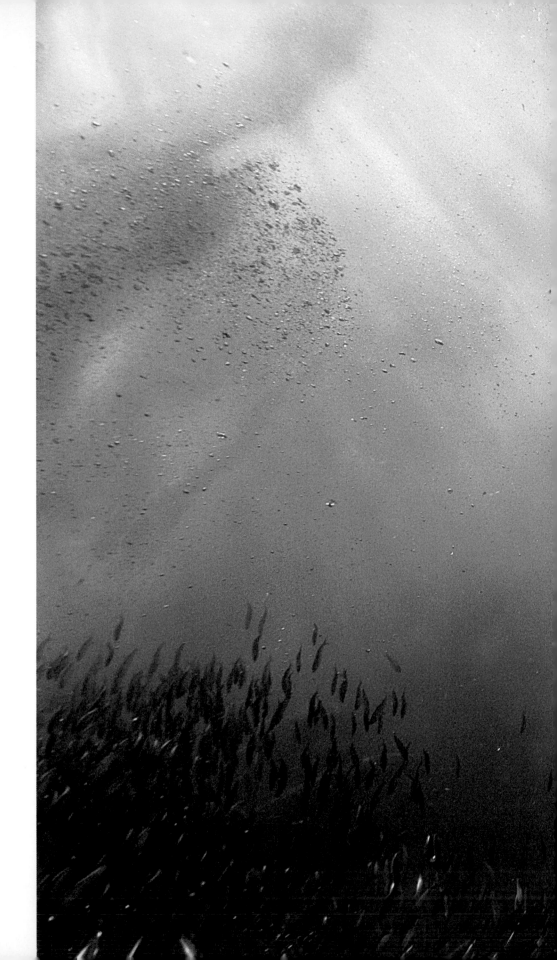

The plunge diver

RUNNER-UP

Alexander Safonov

RUSSIA

The 'sardine run' is one of the world's great migration events, taking place every winter off the Southern Cape. Alexander's dive base for photographing the huge northern movement of Pacific sardines was Port St Johns, South Africa. The shoals were being attacked by a congregation of predators, from sharks and dolphins to seals and birds. But what intrigued Alexander the most were the diving seabirds, in particular the Cape gannets, which were plunging into the water at speeds exceeding 60kph (37mph) to depths of 10 or so metres (33 feet) as they chased the sardines. 'I came across this scene', says Alexander, 'one beautiful morning while diving among a baitball.' To capture it, Alexander had to learn blind-shooting techniques, as 'the viewfinder is almost useless for taking close-ups of fast-moving birds under water.' The setting for the silver 'flying' gannet – a surreal backdrop of slicing sunbeams, glistening scale particles, corkscrew dive trails and diving fish – created the unforgettable image.

Nikon D300 + Nikkor 12-24mm lens; 1/400 sec at f10; ISO 200; Sea&Sea MDX-D300 housing.

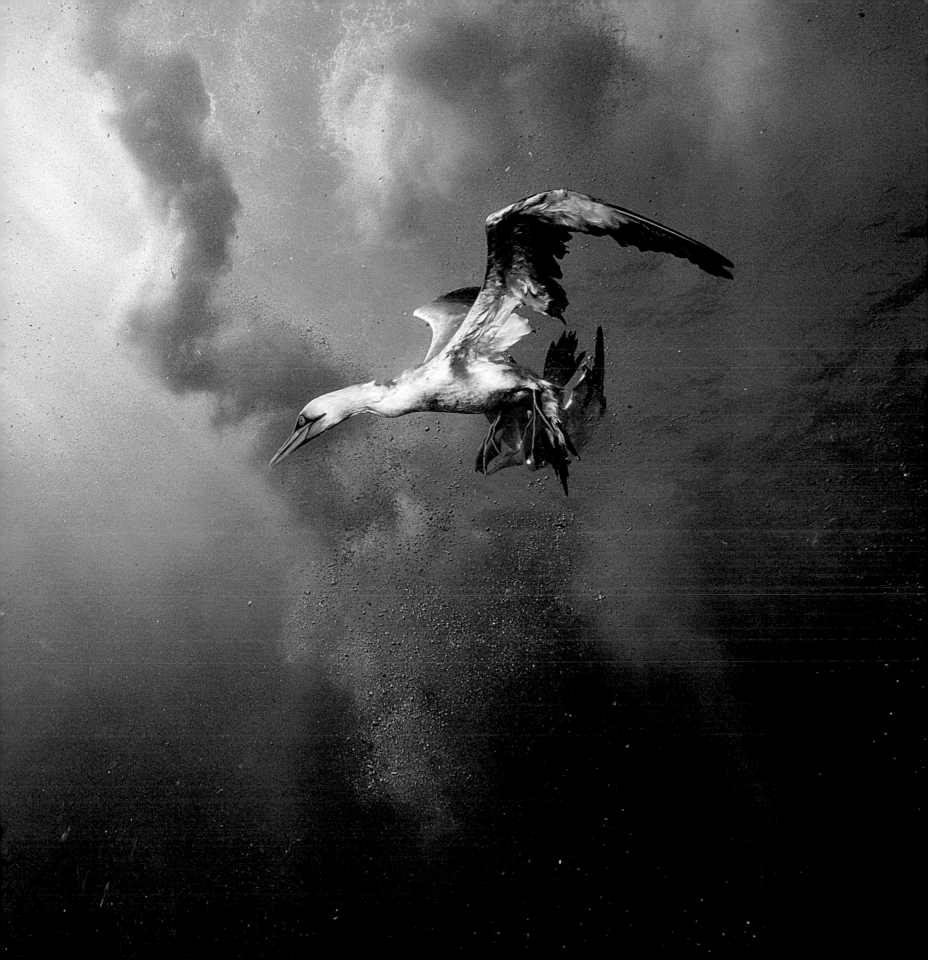

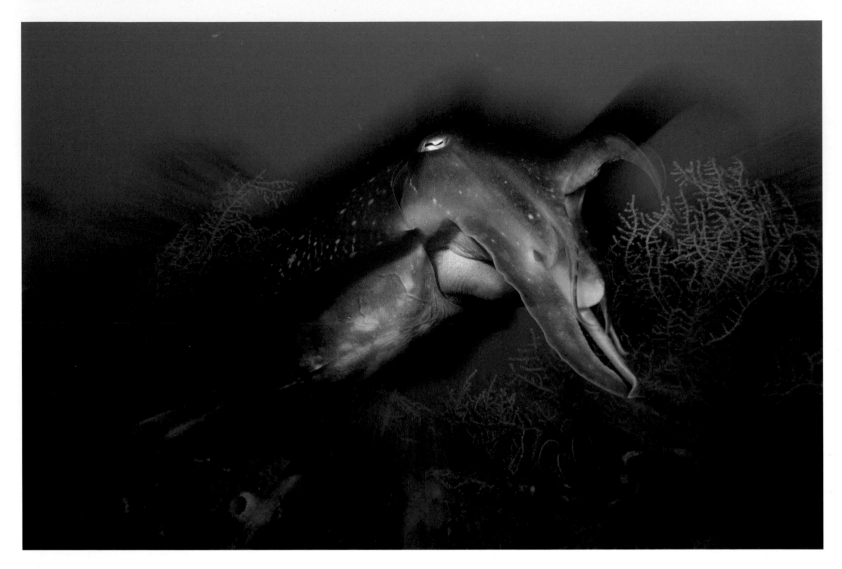

Cuttlefish glow

HIGHLY COMMENDED

Christopher Guglielmo

USA

After many encounters with cuttlefish in various countries, Christopher was looking for a portrait with extra edge. While diving in Bunaken National Park, Indonesia, he was approached by this large broadclub cuttlefish. 'It seemed fascinated by me and checked me out for more than 20 minutes,' says Christopher, 'pulsating with colour and undulating its arms.' Of course, it might just have been signalling at its own reflection in the glass dome of Christopher's camera housing.

Nikon D2X + Nikon 18-70mm lens; 1/10 sec at f14; ISO 100; Aquatica housing; dual Ikelite DS-125 strobes.

River sparring

HIGHLY COMMENDED

Kevin Schafer

USA

In tannin-rich water in a tributary of the Rio Negro, a pair of Amazon river dolphins, square up to each other 'They are rambunctious, intensely social, often competitive,' says Kevin, and the bodies of males are raked by teeth-marks. Their 'beaks' are formidably strong and as effective as a crocodile's, according to Kevin, who spent several weeks in the water with the botos 'recording their behaviour for the first time ever.'

Nikon D200 + Nikkor 12-24mm DX lens; 1/160 sec at f4; ISO 320; Sea&Sea DX-D200 housing.

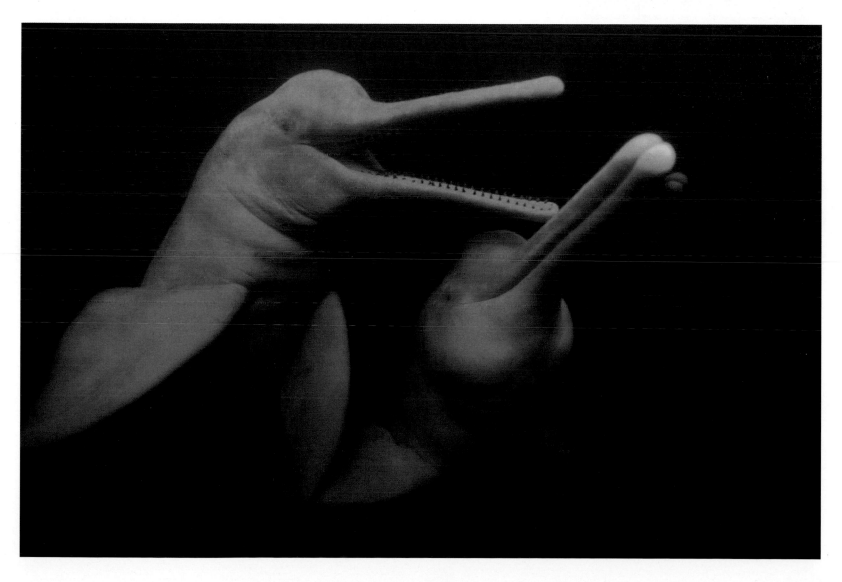

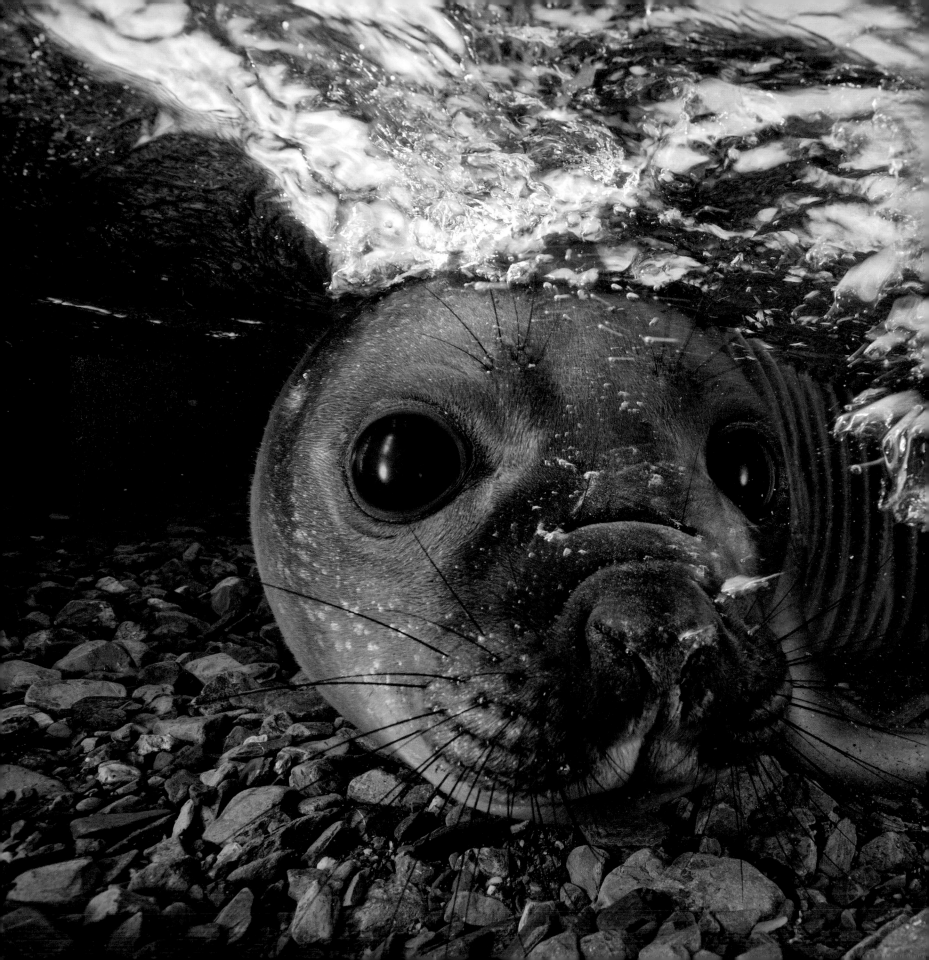

Water baby

HIGHLY COMMENDED

Paul Nicklen

CANADA

A young southern elephant seal pup rests in a freshwater creek in Fortuna Bay, South Georgia. His 36kg (80 pounds) birth weight had soared to about 180kg (400 pounds) in fewer than three weeks. Now weaned, he had been left to fend for himself. Constant storms meant that the seawater was too murky for underwater photography, but Paul was desperate to get images of elephant seals. He eventually found this young seal playing in a crystal-clear freshwater creek, and joined it in the water for more than two hours. 'After waiting months in vain for a picture of a polar bear in the Arctic,' he says, 'here I was on the other side of the world, being mobbed by countless curious animals, including this plump and healthy seal. South Georgia is one of the most astonishing wildlife hotspots I have been to.'

Canon EOS-1Ds Mark III + Canon EF 16-35mm f2.8L II USM lens; 1/100 sec at f13; ISO 200; Seacam housing; dual Ikelite SS-125 strobes.

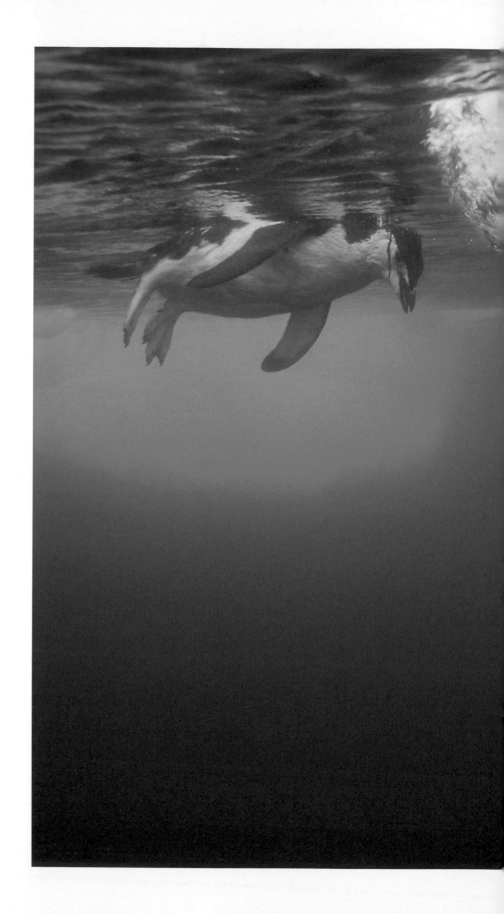

Bubble talk

HIGHLY COMMENDED

Paul Nicklen

CANADA

'After trying to feed me penguins for four days,' says Paul, who was photographing on Anvers Island off the Antarctic Peninsula, 'this massive female leopard seal started showing classic signs of frustration by blowing bubbles at me.' Despite her size (nearly 3 metres – 10 feet – long), Paul didn't feel this was aggression and so kept on shooting. He concluded that she was not just trying to offer him penguins to eat but, more importantly, making an attempt at communication, trying to figure out what his intentions were. 'It was, and probably will be, the most amazing wildlife encounter of my career.'

Canon EOS-1Ds Mark II + Canon EF 16-35mm f2.8L II USM lens; 1/160 sec at f9; ISO 400; Seacam housing; Ikelite SS-125 strobes.

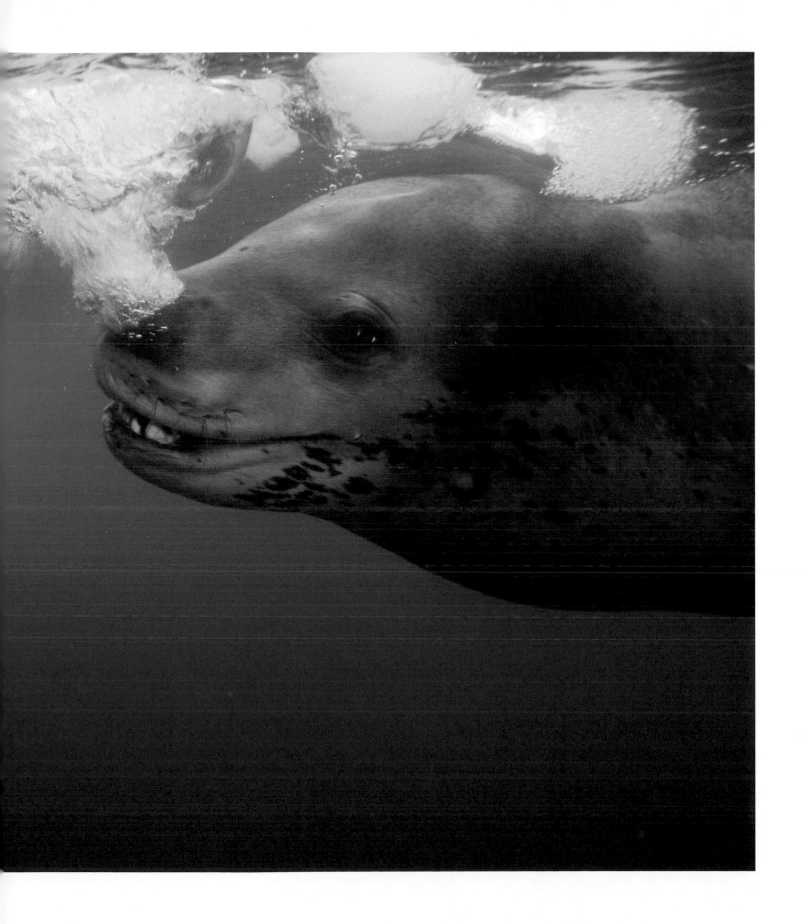

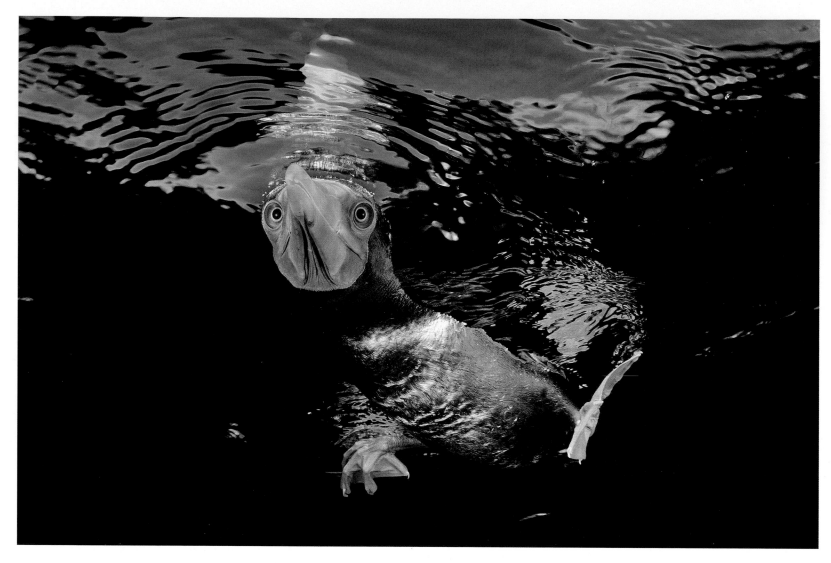

Goggling booby

HIGHLY COMMENDED

Nano Cordovilla

SPAIN

As Nano ascended from a deep dive off the
Revillagigedo Archipelago, Mexico, he made a
safety stop 4 metres (13 feet) below the surface.
As he looked up, this animal looked down.
'I'm not sure who was the more surprised,' says
Nano, 'but I must have looked as goggle-eyed as
the bird.' The booby continued to investigate
Nano and even pecked at its reflection in the glass
dome of his underwater housing. The flashes give
the plumage its metallic sheen.

**Nikon D300 + Tokina 10-17mm lens; 1/200 sec at f16; ISO
200; dual Sea&Sea YS-250 strobes.**

Curious lemon

HIGHLY COMMENDED

Dániel Selmeczi

HUNGARY

Tiger Beach, as its name suggests, is a tiger-shark hotspot, which is what attracted Dániel to the Bahamas. One morning, friendly lemon sharks gathered round his boat, but 'it felt a bit early to get in the water,' says Dániel, 'so I sat on the end of the boat with my camera rig submerged' – a simple technique that proved highly effective. Sadly, the number of lemon sharks were far fewer than in past years, mainly because their mangrove nurseries are being destroyed by coastal development.

Nikon D300 + Tokina 10-17mm lens; 1/250 sec at f14; ISO 400; Subal housing; dual Subtronic flashes; remote control.

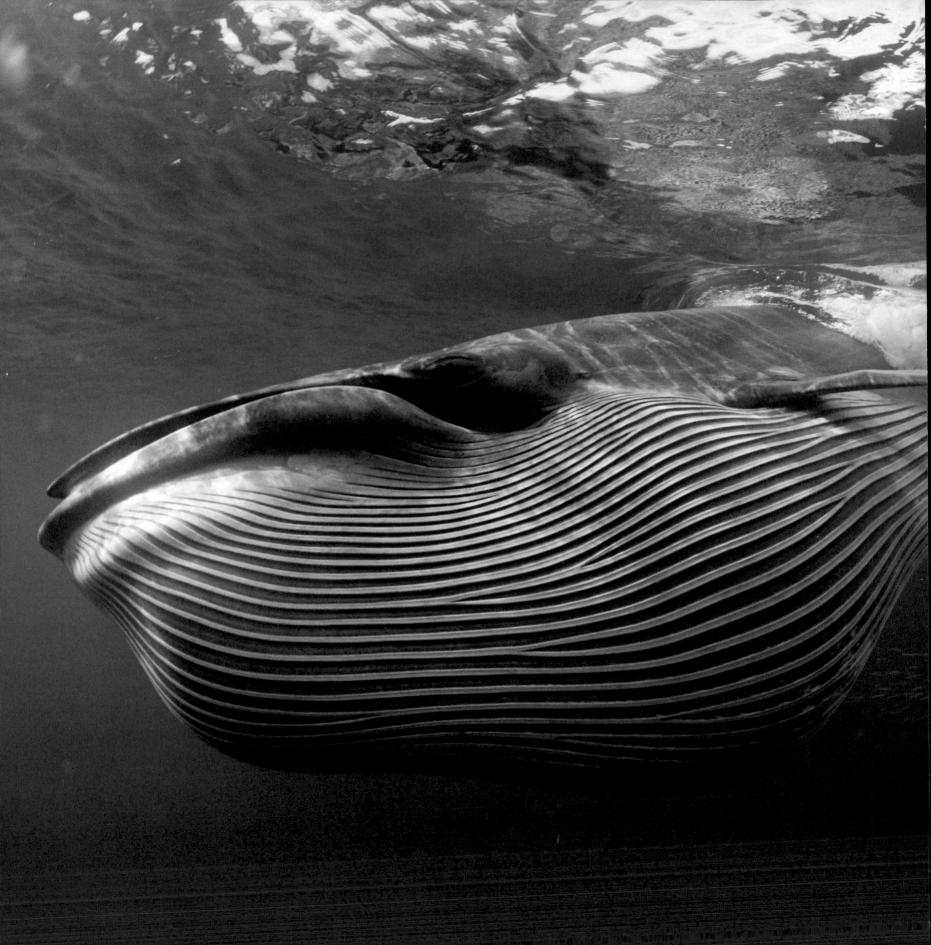

Big-mouth

HIGHLY COMMENDED

Doug Perrine

USA

Doug was on Golden Gate Bank off the southern tip of Baja California, Mexico, to photograph striped marlin feeding on shoaling sardines. Hunting cooperatively, the marlin herded the fish into baitballs and up towards the surface. When the marlin suddenly made a sharp exit, Doug had an ominous feeling that something was up. And that 'something' was a 10-metre (33-foot) 'high-speed missile blasting through the baitball': a Bryde's whale. 'Just before reaching the sardines,' Doug says, 'the whale opened its jaws impossibly wide and the throat pleats expanded to take in water and fish.' And nearly Doug, too: he narrowly missed the open mouth, bouncing off the whale's lower lip and the side of the throat pleats. The huge gulp complete, the whale's jaws closed and the accordion-like pleats forced the water out through the baleen hanging from the upper jaw, trapping the sardines on the inside. Taking no notice of the human presence, the whale repeated its transformation from torpedo to big-mouth enough times for Doug to capture the action.

Canon EOS 40D + Tokina 10-17mm lens at 10mm; 1/640 sec at f5.6; ISO 640; Subal C40 housing.

One Earth Award

The pictures in this category can be graphic or symbolic but must be thought-provoking and memorable and encourage respect or concern for the natural world and our dependence on it.

The lone fir

WINNER

Thomas Haney

USA

It was late afternoon when Thomas came upon this scene outside Forks, Washington, while documenting old-growth logging in the Pacific Northwest. Loggers had left a single Douglas fir standing in a clearcut area, perhaps to help reseed the area for future logging. 'As I walked towards it on the muddy road, criss-crossed with the tracks of logging trucks, I saw the reflection in the puddle,' says Thomas. 'It was a powerful image, reminding me of the towering forest that once stood here,' he says. This area has been logged before, so this tree is likely to have been planted as part of a mono-age crop, vastly different from the multilayered forests that once blanketed the region. 'Clearcutting has long been a focal point of the environmental movement, and while it seems to be falling out of favour in North America, it's still the preferred method around the world.'

Minolta Maxxum 7 + Minolta 20-35mm f3.5-4.5 lens, + .3 graduated-split neutral-density filter; 2 sec at f16; Fujichrome Velvia 50.

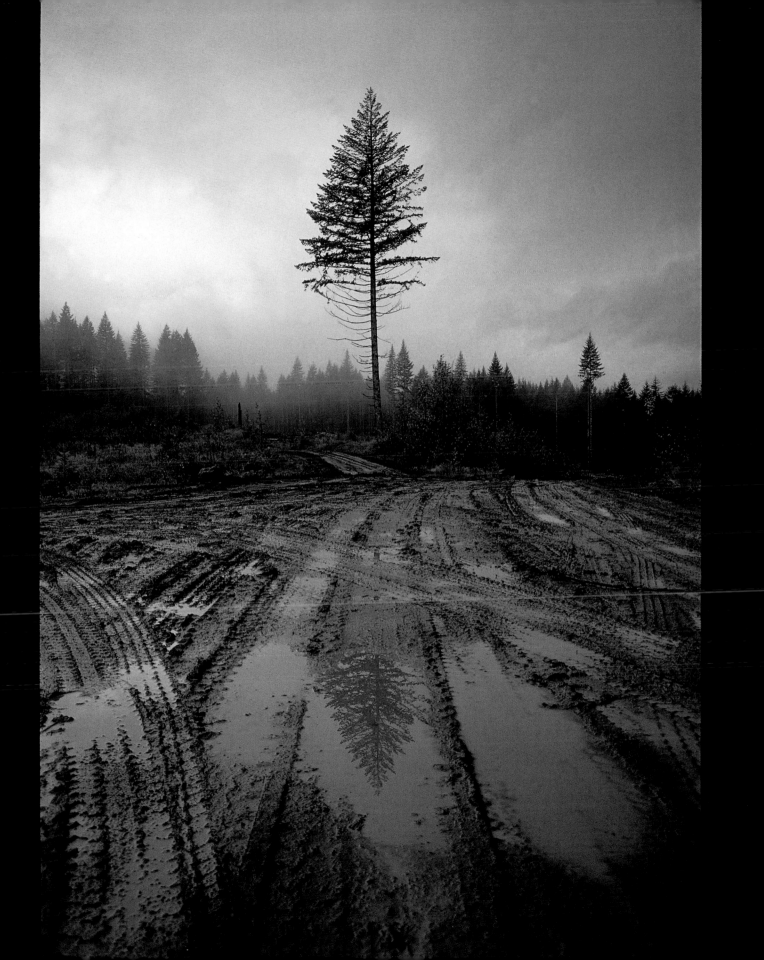

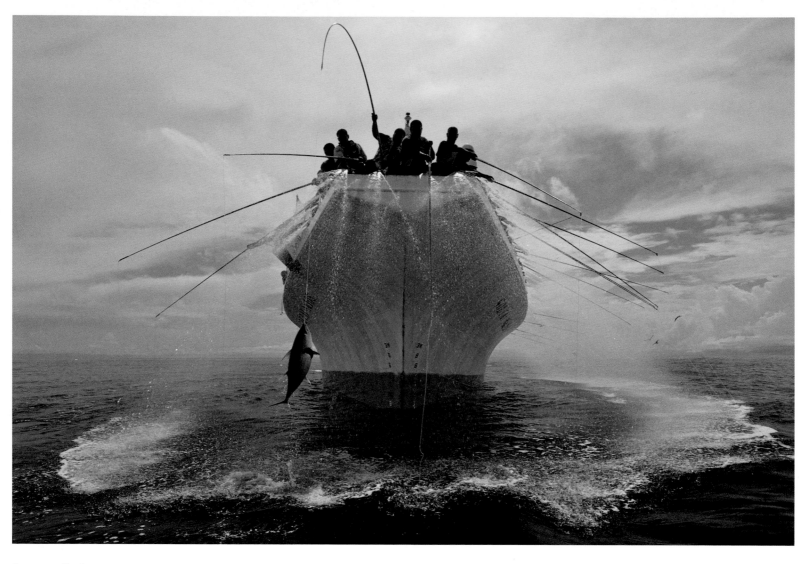

Last of the tuna

HIGHLY COMMENDED

Jonathan Clay

UNITED KINGDOM

A Solomon Islander catches a yellowfin tuna off New Georgia on one of the last pole-and-line boats in the South Pacific. The fishery has now closed, losing out to purse-seining operations. Pole-and-line fishing targets fish of a specific age and species, unlike purse-seining, which encircles everything in the path of the nets, including sharks and turtles. 'If shoppers buy tins of "sustainably caught" tuna,' says Jonathan, 'it will give a future to vessels such as this one and a better deal for marine life.'

Canon 30D + Canon EF-S 10-22mm lens; 1/500 sec at f4.5; ISO 100.

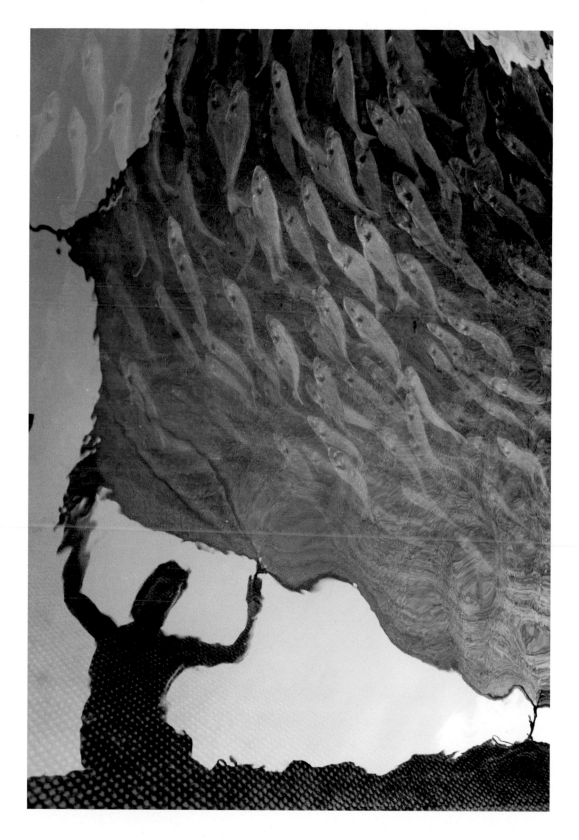

Reflections on fish

RUNNER-UP

Frédéric Larrey

FRANCE

As the fish-farmer checked his stock before nightfall, Frédéric set out to take a photograph that would tell a story. The intention was to portray the act of covering the fish cages in such a way that it would look like a fisherman throwing a net over a shoal of wild fish. In the cages are gilthead seabream, a popular dish throughout Europe and a favourite fish-farm species. There are many environmental implications of raising captive fish for food. This, though, is the first organic fish-farm in France, in the sea by the islands of Frioul, off Marseille. Its guiding principles are respect for the environment, the animals and the consumer. 'The image seemed so symbolic,' says Frédéric, 'all those fish sweeping into the net's reflection – a reminder of the devastating effects of overfishing.'

Canon EOS-1Ds Mark II + Canon EF 24-70mm f2.8 L USM lens at 24mm; 1/160 sec at f2.8; ISO 640.

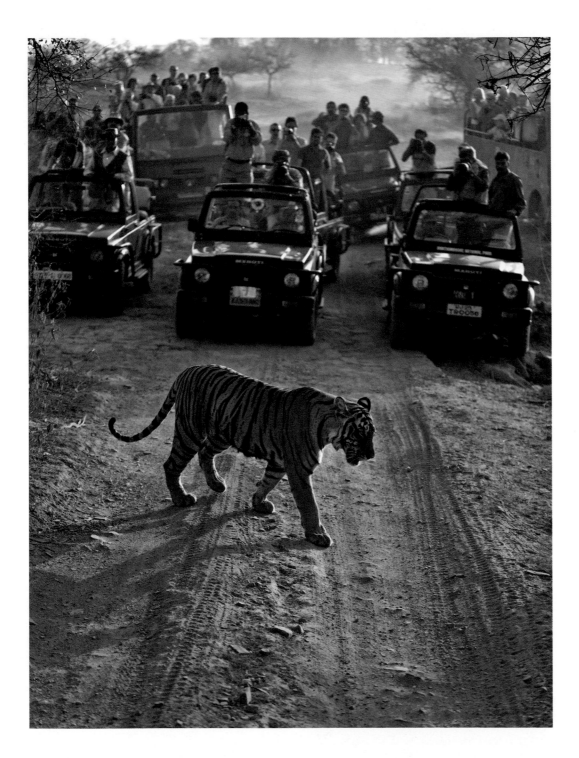

Stalking the tiger

HIGHLY COMMENDED

Andy Rouse

UNITED KINGDOM

Andy and his guide Dicky Singh followed the fresh pug marks down the track. When they caught up with the tiger, they discovered it was Machali, a female very familiar to Dicky. Indeed, she's something of a local celebrity in Ranthambore National Park. It wasn't long before jeep-loads of tourists drew up to admire her. The drivers kept a respectful distance, but Machali is well used to such attention from the wildlife paparazzi. It has been suggested that Machali has contributed about $10 million to the local economy. Andy believes that 'if we are to save this wonderful cat, then it has to have an economic value to a local community, and that's what I wanted to show with this picture.'

Nikon D3 + Nikon 70-200mm lens; 1/250 sec at f5.6; ISO 800.

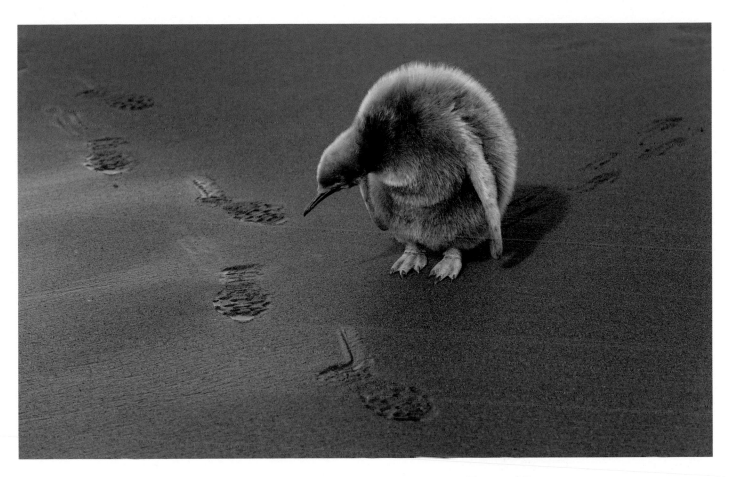

Footprints

HIGHLY COMMENDED

Robert Friel

UNITED KINGDOM

Walking along the beach at Gold Harbour, South Georgia, Robert became fascinated by the footprints left by the king penguins as they returned from the sea to feed their chicks. 'When I'm walking, I always take time to stop and look back – it gives a different perspective, and I always see something different,' says Robert. This time, he saw a chick approach his own footprints. 'It stopped and gazed at them intently. It's a quirky moment, but it's also a reminder that, however brief and well-managed our visits, our presence leaves a mark.'

Canon EOS-5D + Canon EF 24-105mm f4L IS USM lens at 105mm; 1/250 sec at f4; ISO 50.

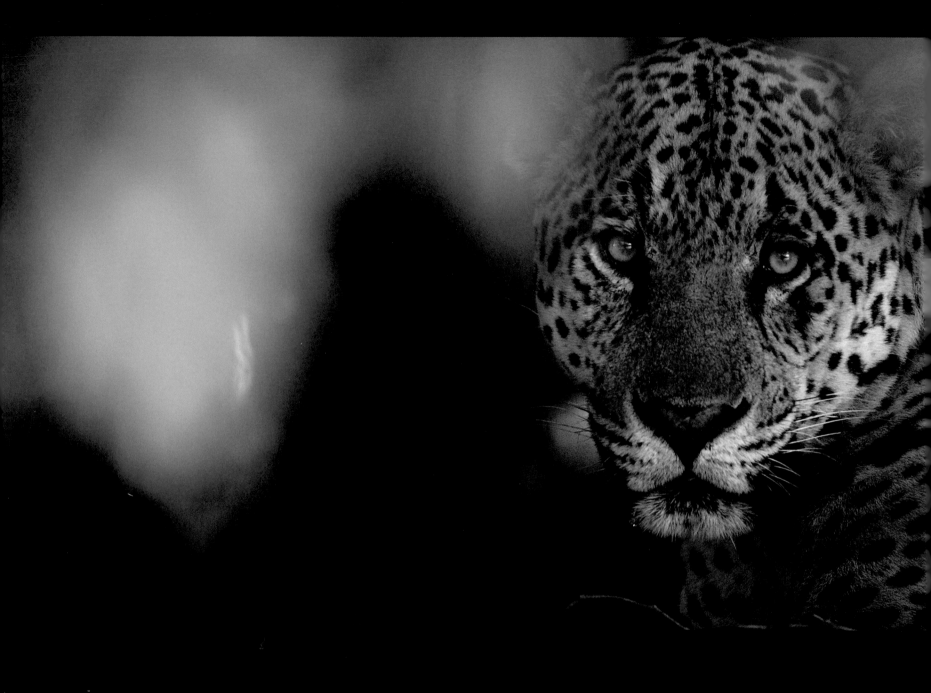

Gerald Durrell Award for Endangered Wildlife

The subjects featured here are species officially listed as critically endangered, endangered, vulnerable or at risk, and the purpose of the award is to highlight, through photographic excellence, the plight of wildlife under threat.

The look of a jaguar

WINNER

Tom Schandy

NORWAY

In a small, protected area of swamp-forest in the western area of the Pantanal wetland, in Mato Grosso, Brazil, jaguars still roam free from human harassment. They're notoriously difficult to see, and pawprints are as lucky as most people get. Along the riverbanks, though, it's possible to spot them. When Tom took a boat down the Rio Paraguay, he saw four jaguars in three days. This male had picked a slightly concealed spot where he could watch for prey such as capybara. Tom observed him for an hour. 'He was totally calm, even though he was aware of us.' At sunset, the jaguar rose, yawned and scent-marked. Then he faded back into the dense forest.

Canon EOS-ID Mark III + 500mm f4 lens; 1/250 sec at f4; ISO 400; beanbag.

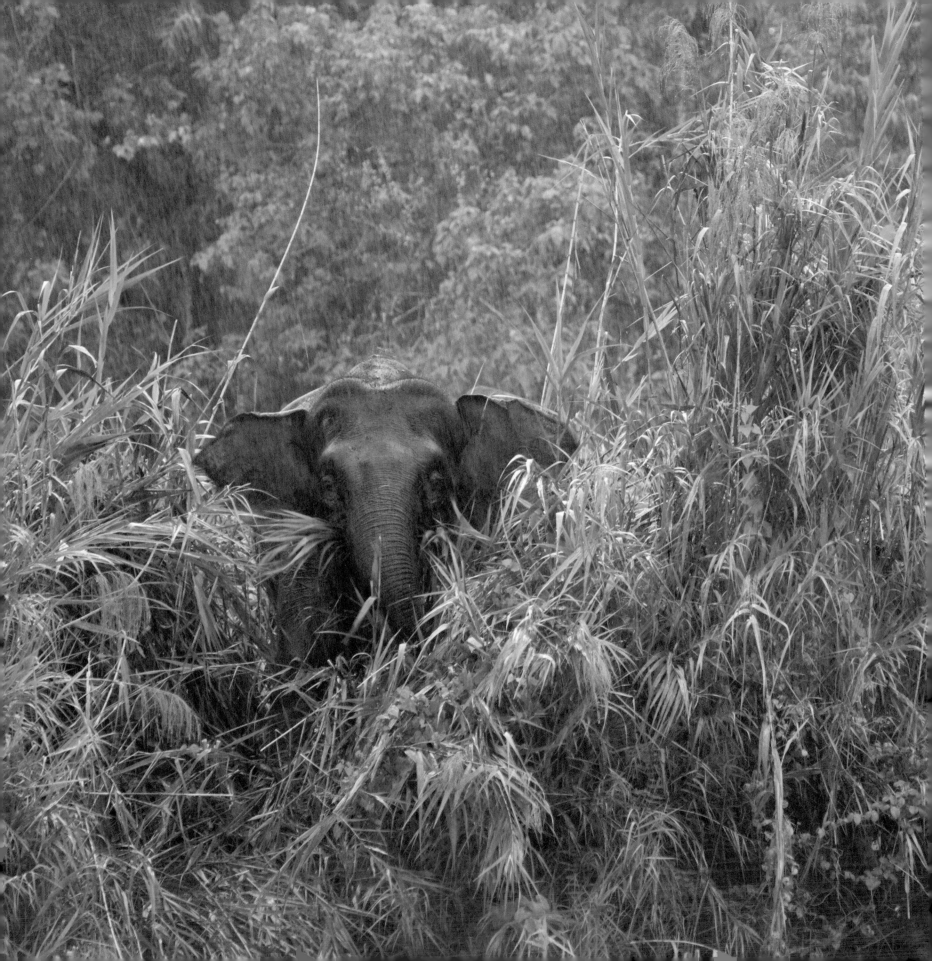

Elephant onlooker

RUNNER-UP

Juan Carlos Muñoz

SPAIN

Not only are pygmy elephants critically endangered, but they also favour thick forest, which meant that Juan Carlos had his work cut out trying to find any. As he travelled by boat down the Kinabantangan River in Sabah, Borneo, the heavens opened. 'It was so torrential,' says Juan Carlos, 'that I couldn't decide what I was more worried about, the boat sinking as it filled up with rain or how to protect my camera gear.' Suddenly the undergrowth parted and a male pygmy elephant looked out. Slowly munching on leaves, he serenely watched the ongoing boat chaos through the sheets of rain, giving Juan Carlos the chance to take his portrait before the elephant melted back into the forest. Pygmy elephants are found only on the island of Borneo and were classified as a subspecies of the Asian elephant in 2003.

Canon EOS-1Ds Mark II + Canon 100-400mm lens; 1/60 sec at f5; ISO 400.

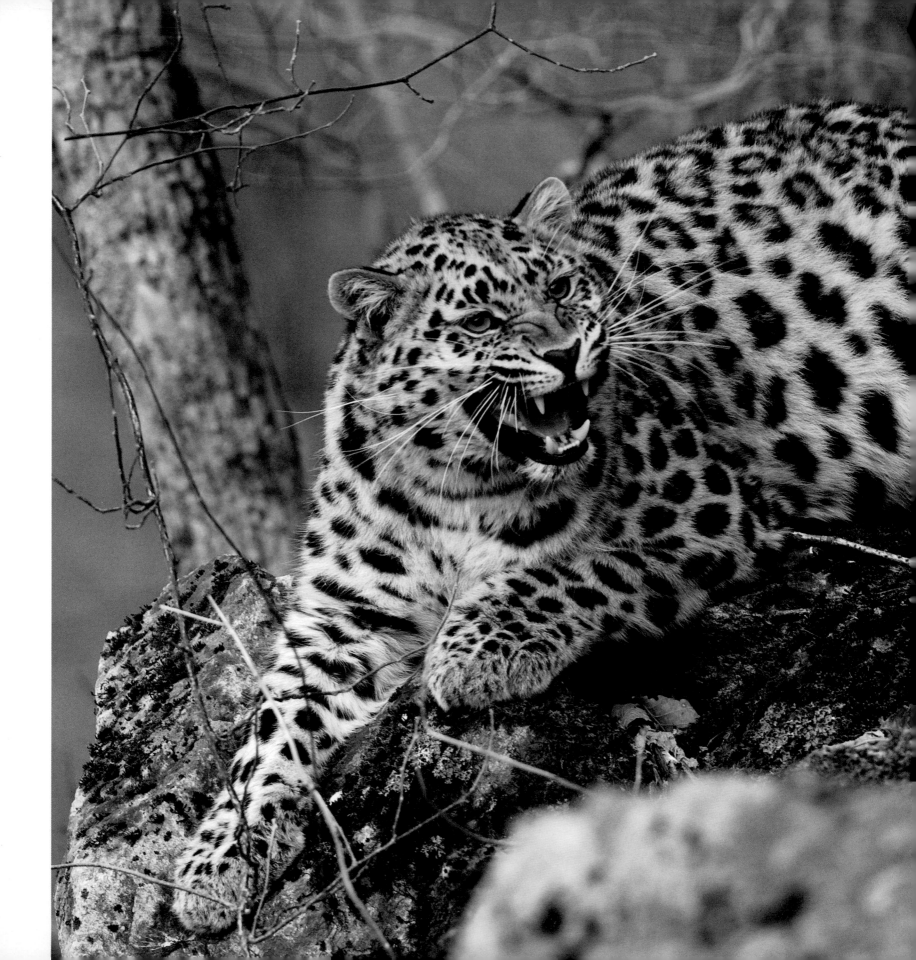

Lure of the leopard

HIGHLY COMMENDED

Andrew Harrington

UNITED KINGDOM

Andrew spent two weeks in a hide in Kedrova Pad Reserve in the Russian Far East trying to photograph one of the world's rarest cats. Today, no more than about 25 Amur leopards survive. 'I spent 20 hours a day looking out through a gap the size of a letterbox,' says Andrew. 'Day after day, the only animals I saw were jays and tits.' But he had set up his hide near a feeding station, and eventually this young male arrived. Though nervous, it was more annoyed by a lurking jay, which it attempted to scare off by snarling. The population of the Amur leopard (a subspecies) has been decimated by poaching for its skin and bones, habitat destruction and loss of prey and is now also inbred – this leopard's father is probably his grandfather, too. Now Russian/Chinese plans for a transboundary park may lessen the likelihood of the Amur leopard becoming extinct in the near future *if* it can be given sufficient protection.

Nikon D2X + Nikon 200-400mm lens; 1/60 sec at f4; ISO 200.

Queen of the Philippines

HIGHLY COMMENDED

Klaus Nigge

GERMANY

Her head feathers slightly raised in mild curiosity, a Philippine eagle gazes towards Klaus's hide. The mountain rainforest of Mount Kitanglad, in Mindanao, Philippines, is one of this eagle's last remaining breeding sites. Some estimates put the population at just a few hundred individuals. This female spent much of her time at her nest, standing guard over her eight-week-old chick. Sometimes, though, she would take a break and perch on a nearby limb some 100 metres (320 feet) away – not to do anything in particular, but simply to put a bit of distance between herself and her nesting duties. 'There is no drama here,' says Klaus, 'no swooping or screeching. She's simply doing what she mostly did, most days.'

Nikon D2X + 800mm f5.6 lens; f7.1 at 1/20 sec; ISO 250.

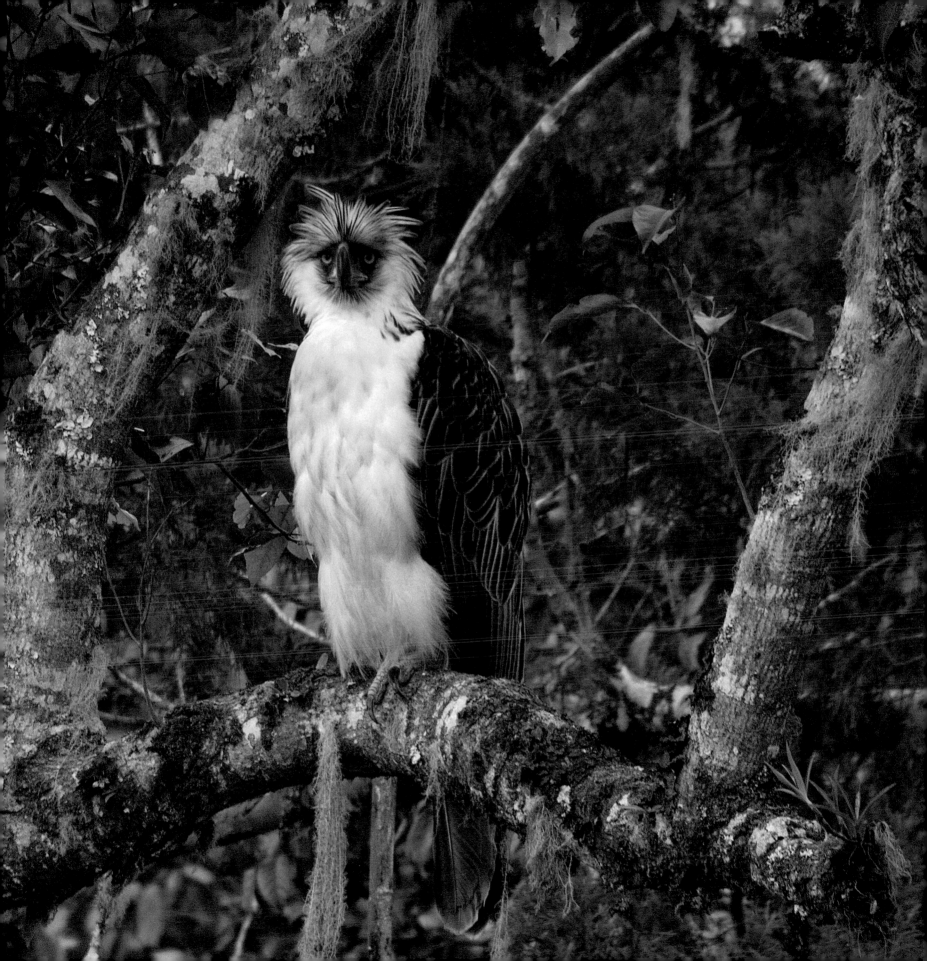

The Veolia Environnement
Young Wildlife Photographer
of the Year Award

The title Veolia Environnement Young Wildlife Photographer of the Year 2009 and a cash prize goes to Fergus Gill – the young photographer whose image has been judged to be the most memorable of all the pictures by photographers aged 17 or under.

Fergus Gill
UNITED KINGDOM

Fergus Gill lives in rural Perthshire, Scotland, surrounded by farmland, woodland and moorland, giving him plenty of opportunity to get close to nature. He took his first photographs at the age of nine, with an interest sparked by his father, who encouraged him to concentrate on subjects close to home. This interest developed into a passion when, in 2004, he won the 11-14 age category in the Young Wildlife Photographer of the Year competition. Then in 2007 he won his age category again, with a shot of a sparrowhawk taken in his garden. Fergus is planning to study environmental science when he leaves school next year, but eventually he very much hopes to find a way to earn a living as a professional wildlife photographer.

Clash of the yellowhammers
WINNER (15-17 YEARS)

The planning for this picture started in the summer, when Fergus collected sheaves of oats from a local farmer specifically as winter food for the yellowhammers. One evening in February, hearing that snow was forecast for the next morning, Fergus set up his hide in the garden, hung out feeders and carefully positioned a sheaf of oats. 'I woke early and got into the hide to wait. After a few hours, the garden was full of birds. At one point I counted 32 yellowhammers feeding on the ground.' After another couple of hours, more snow fell and the yellowhammers began jumping up and feeding on the sheaf. 'Every so often I would see a fight between two males over ownership of the oats,' says Fergus, 'but the spats were incredibly fast.' This, however, was the event he decided to concentrate on. Two days later, Fergus got his shot, capturing both the clash and the composition he'd planned.

Nikon D300 + Nikon 200-400mm f4 lens at 220mm; 1/1000 sec at f5.6; ISO 500.

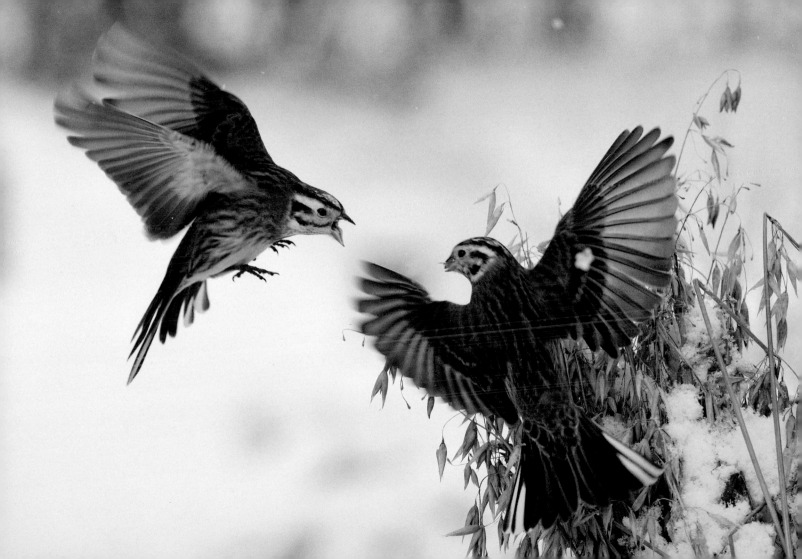

Moonlight rap

RUNNER-UP

Niko Pekonen

FINLAND

Tap-tap-tap ... a distinctive knocking sound echoed through the wood near Niko's home in Joensuu, eastern Finland. It was winter, and the sun had already set, but Niko decided to try to track down the drummer. He soon found it – a white-backed woodpecker, rapping industriously on tree trunks in search of juicy bugs tucked under the bark. The light had almost gone, and Niko was about to go home when he noticed that the moon had risen. He moved around the tree to where he could see the spot where the woodpecker was at work, illuminated by a dab of moonlight, and then composed the shot so that the moon itself was a key element .

Canon EOS 30D + Canon EF 100-400mm f4.5-5.6 IS USM lens; 1/250 sec at f8; ISO 800.

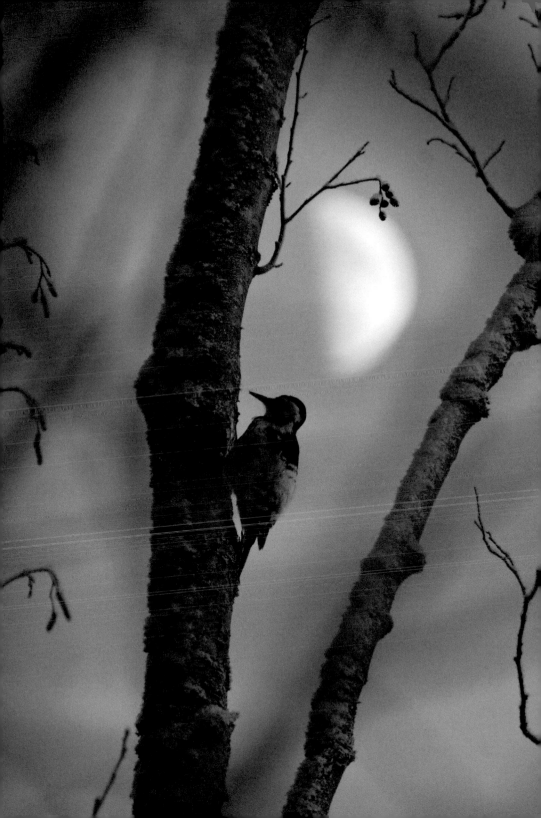

Feather-care

HIGHLY COMMENDED

Aleksander Myklebust

NORWAY

Aleksander spent the whole day in a hide near Lake Hornborgasjoen, Sweden, photographing common cranes. About 12,500 had gathered on a field behind the lake. 'Many were busy preening their feathers, and I thought it would be fun to try to photograph that, without any distracting elements in the background. It was a fantastic experience to sit there, just a few metres away from these great birds.'

Canon EOS 40D + Canon EF 300mm f4L IS USM lens at 300mm; 1/2500 sec at f5.6; ISO 400.

Squirrel mouthful

SPECIALLY COMMENDED

Jacek Kwiatkowski

POLAND

Jacek had spent a very cold morning in the forest, waiting not only for the right pose but also the right light to take a decent portrait of a red squirrel. He knew the forest well – he has been photographing the wildlife there for eight years. He also knew that the squirrels couldn't resist a bait of hazelnuts. Then, instead of the light getting brighter, snow started to fall. But it turned out to be the perfect conditions for an atmospheric winter shot.

Canon EOS 40D + Canon EF 400mm f5.6L USM lens; 1/125 sec at f5.6; ISO 640.

Winter in Poland can be severe, and when Michal took this shot on the edge of a lake in the Beskidy Mountains, it was cloudy and freezing. He had gone there specifically to take black-and-white shots and was inspired when he found a huge crack leading from the frozen lake up to the tree. Using a wide-angle lens and an overexposure, he created an abstract image showing the tree and the crack as one and conjured up his impression on first seeing the crack that the tree was erupting from the ice.

Nikon D80 + Nikkor 18-70mm f3.5-4.5G lens; 1/10 sec at f16; ISO 100.

Deer at dawn

HIGHLY COMMENDED

Daniel Szabo

HUNGARY

It was dawn when Daniel arrived at the forest of Csapod near his home in Hungary. The late-autumn colours were muted by the mist, and with no wind, the trees were still and silent. He knew where the red deer might be and moved quietly into the forest. The hind was feeding in a glade, and as Daniel got into position, she paused and looked towards him, as if sensing his presence. He slowly raised his camera and focused, deliberately keeping the deer silhouetted against the early morning light and framed by the forest to create a picture that would convey some of the magic of the encounter.

Sony DSLR-A100 + Sony 75-300mm lens; 1/250 sec at f4; ISO 100.

Royal headgear

WINNER

Sam Rowley

UNITED KINGDOM

Rising early on an autumn morning, Sam set out to stalk the red deer in Richmond Park, one of London's royal parks. The park red deer are used to people, and so when Sam saw this magnificent stag he was able to creep to within 5 metres (16.5 feet) of it. The stag had a full set of antlers, ready to clash with other males during the autumn rut, and was thrashing vegetation to get rid of the irritating remains of the velvet that had covered them. As he raised his head, he took the bracken with it, creating a magnificent natural crown against the rising sun.

Nikon D200 + VR Nikkor 70-300mm f4.5-5.6G lens; 1/8000 sec at f5.6; ISO 800.

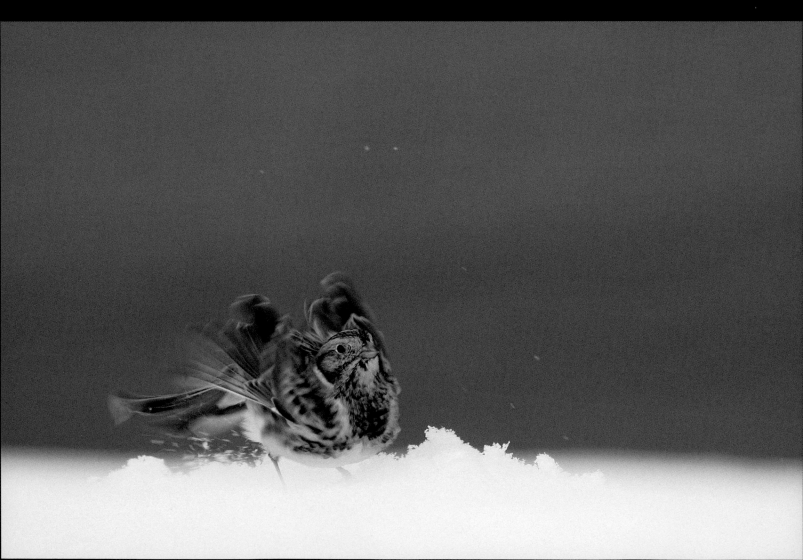
Canon EOS 450D + Canon EF 100-400mm f4.5-5.6L IS
USM lens; 1/400 sec at f7; ISO 250.

White-out

RUNNER-UP

Stephan Rolfes

GERMANY

A sudden snowfall in late November provided the perfect setting for photography. But when fog set in and the visibility dropped to 50 metres (165 feet), Stephan decided to 'start looking for beautiful trees' rather than animals. He finally discovered these two, 'full of snow'. But what he especially liked was the way the fog erased the horizon. Using a fast shutter-speed, Stephan captured the almost two-dimensional nature of the scene, the trees etched into the white background.

Nikon D300 + AF-S VR Zoom-Nikkor 200-400mm f4G lens at 280mm; 1/2000 sec at f5; ISO 400; tripod.

Fungal forest

HIGHLY COMMENDED

Hans Nuijt

THE NETHERLANDS

Every day after school, Hans headed to an arboretum near his home in Rhenen, the Netherlands, to photograph the autumn fungi. These fly agarics became his passion. 'From above, they looked small,' says Hans, 'but once I got down on the ground, they became huge.' He didn't want the fungi to be central in the image and set them to one side, so the stipes of the fruiting bodies are echoed by the trunks of the birch trees. 'That way, you are drawn into the picture,' he explains, 'your eye moving down the avenue.'

Nikon D50 + Sigma 17-70mm f2.8-4.5 DC Macro lens at 70mm; 1/4 sec at f25; ISO 200.

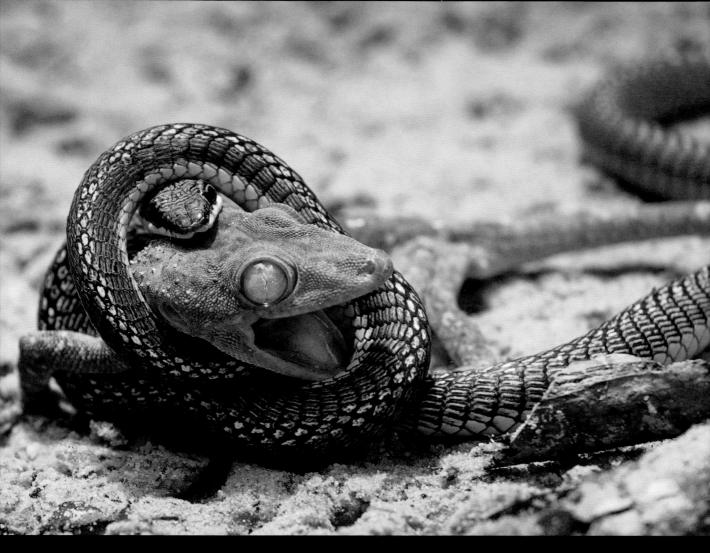

Intimate death

HIGHLY COMMENDED

Miles Kenzo Kooren

THE NETHERLANDS

Thud! Something fell out of a tree and landed on
the sand near where Miles and his sister were
cooling off in a lagoon in the Lambir Hills National
Park, Sarawak, Borneo. A small snake was wrapped
tightly around a gecko. 'Paradise tree snakes can
kill small prey, but they're not dangerous to humans,'
says Miles, who lay really close on the ground and

Super swift

HIGHLY COMMENDED

Stephan Rolfes

GERMANY

While on holiday on the island of Rügen in the Baltic Sea, Stephan discovered an old barn where swifts were raising their young in nests in the wall cavities. The challenge he set himself was to photograph one of these super-swift birds in flight. 'They were moving so fast', he says, 'that it was almost impossible to get them in frame.'
After a lot of failed attempts, he worked out how to anticipate the swift's trajectory and captured not only a pin-sharp image against an azure backdrop, but also a perfect composition with the swift looking directly at the camera.

Nikon D300 + AF-S VR Nikkor 70-200mm f2.8G lens; 1/3200 sec at f4; ISO 400.

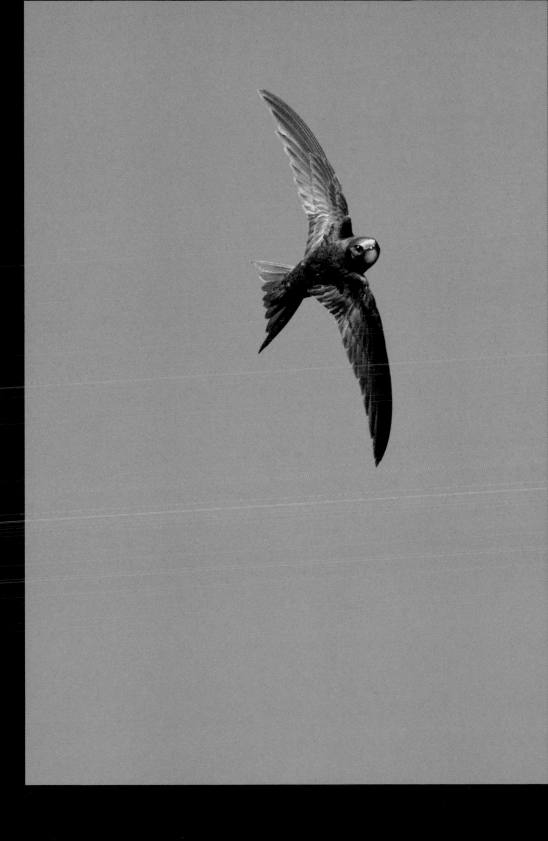

Spider-monkey walk

HIGHLY COMMENDED

Louis de Montfort

UNITED KINGDOM

Louis took this shot of a spider monkey while on holiday with his family in Costa Rica. Canoeing along a river in the rainforest of Tortuguero, eyes peeled for wildlife on the bank, he heard the sound of monkeys. As he approached an overhanging tree, he spotted them. Against the sky and with dull light, it was difficult to see the monkeys properly, but Louis realized there was potential for a very different kind of shot. With his camera set up, he waited under the tree. 'As soon as this monkey stepped onto the leaf-framed branch,' says Louis, 'I took my chance in the fading evening light.'

Sony Cyber-shot DSC F828; 1/1000 sec at f8; ISO 64.

Reflections

WINNER
Ilkka Räsänen
FINLAND

'We have a little pond in our garden,' says Ilkka, 'which attracts all kinds of birds to drink and bathe.' Ilkka loves to watch the behaviour of the birds and has been a serious bird photographer since he was six years old. What attracted him to this greenfinch was the sunlight reflecting off the water onto its green breast. 'The reflections make the photo much more interesting. Without the light play, it would be just a boring bird portrait.'

Nikon D200 + Nikon 300mm f4D lens; 1/160 sec at f6. ISO 250.

Little robin, big song

RUNNER-UP

Noam-Pierre Werlé

FRANCE

It's just an ordinary garden in an ordinary Paris suburb. But this chemical-free oasis has turned into something of a local wildlife hotspot. In fact, Noam-Pierre and his family have recorded more than 40 different species of birds here, from tiny wrens to birds of prey. Noam-Pierre watched this friendly robin for several weeks, getting to know the little bird's habits and favourite perches.
'I took this just before dawn, when the robin was in the middle of a long trill,' he says. 'He looked so tiny. But he was bursting with song, determined to make himself heard.'

Nikon D80 + VR Nikkor 70-300mm f4-5.6 lens; 1/2000 sec at f5.6; ISO 800.

Beaver trail

HIGHLY COMMENDED

Carson Clark

USA

One early evening in late summer, Carson and his father went to photograph a family of American beavers. 'Evening is when the beavers begin to get active,' explains Carson, 'and the light is best. The water was painted green by the tree reflections. My Dad and I are photographing this family of beavers on the Dry Fork River near where my grandmother and uncle live in West Virginia. We've just finished our first children's book together about the beaver family.'

Nikon D80 + VR Nikkor 70-300mm f4-5.6 lens; 1/160 sec at f5.6; ISO 400.

Gull wash and preen

HIGHLY COMMENDED

Ilkka Räsänen

FINLAND

Ilkka eagerly awaits April, when the ice on Lake Saimaa, the largest lake in Finland, starts to thaw and he can get back to photographing birds. When an icebreaker forges a channel, 'I set off into the lake in my floating hide,' says Ilkka. The hide has an electric outboard motor, which he can steer with his feet 'so my hands are free to take photos.' Spotting this herring gull having a wash and preen, he set out to catch the action. 'I always try to take pictures like this – of a bird doing something,' says Ilkka.

Nikon D300 + Nikon 300mm f4D lens; 1/2500 sec at f6.3; ISO 500.

My second bear

HIGHLY COMMENDED

Mimmi Widstrand

SWEDEN

Mosquitoes whined inside the hide in the boggy wilderness near Kuhmo, in Finland, feasting on Mimmi and her parents. But after an hour Mimmi was distracted by something much larger. A brown bear ambled up to the tree in front of the hide and started eating the bacon placed there by another photographer. Using her Dad's camera gear, she snapped away. As the evening wore on, another bear 'walked by, just a metre away,' says Mimmi. 'By then, I was used to them – but my mother wasn't.'

Nikon D3 + AF-S VR Nikkor 500mm f4G lens; 1/640 sec at f4; ISO 640; beanbag.

Call of the cuckoo

HIGHLY COMMENDED

Ilkka Räsänen

FINLAND

Ilkka had never seen a cuckoo, but whenever he had heard one, he would count how many times it repeated its call. Then, one evening, while sitting in a hide in a marsh in southeast Finland, hoping to photograph elk, he heard two male cuckoos calling back and forth. Out of habit, Ilkka started counting. One. Two. Three. Then, suddenly, one of the singers landed right near the hide. Ilkka was concentrating so much on taking photographs that he forgot to carry on counting. 'But I do remember that the call was very loud, and that the bird said "cuckoo" very many times.'

Nikon D300 + Nikon 300mm f4D lens + 1.4x teleconverter; 1/640 sec at f9; ISO 400.

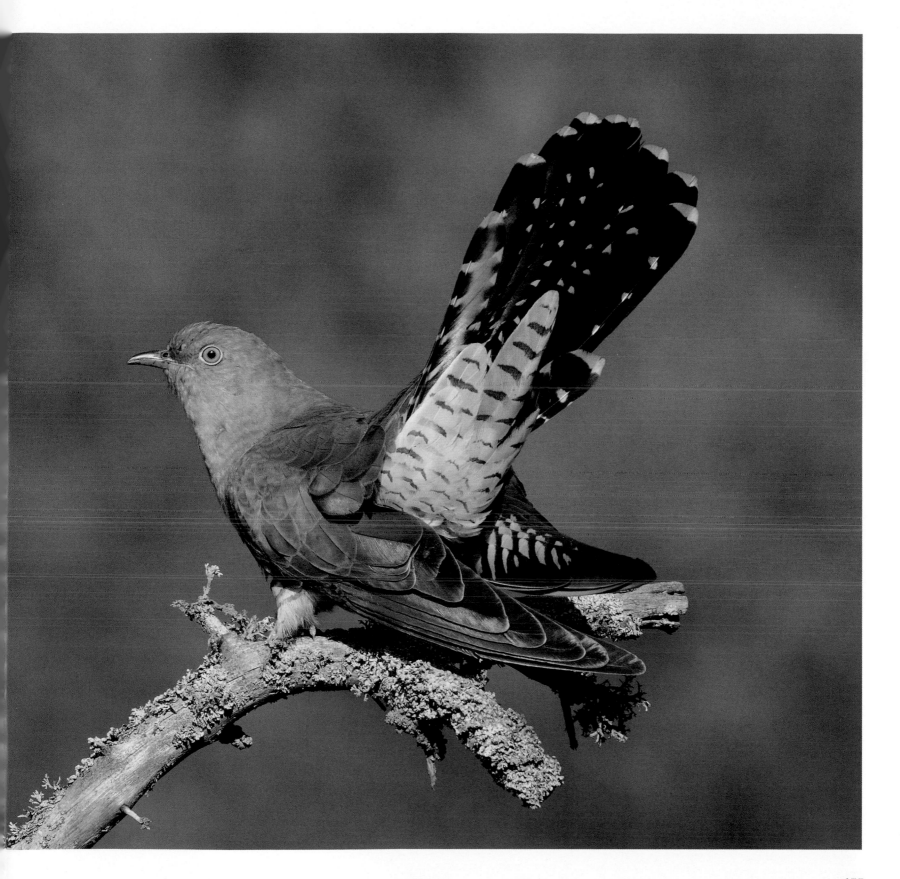

Index of photographers

86
Rob Badger (USA)
rob@robbadger.com
www.robbadger.com

57
Patrick Bentley (Zambia)
info@patrickbentley.com
www.patrickbentley.com

140
Sander Broström (Sweden)
mm_doonuts@hotmail.com
www.regulusphoto.com

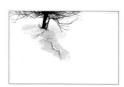

136
Michal Budzynski (Poland)
michal.fp@gmail.com
www.mbudzynski.art.pl

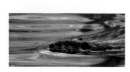

151
Carson Clark (USA)
jimclarkphoto@verizon.net
www.jimclarkphotography.com

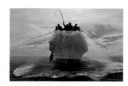

118
Jonathan Clay (UK)
jon@meltingpenguin.com
www.meltingpenguin.com

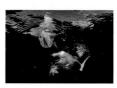

112
Nano Cordovilla (Spain)
nanofotosub@gmail.com
www.flickr.com/photos/nanofotosub/

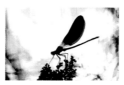

18
Xavier Coulmier (France)
coulmier.xavier@wanadoo.fr
www.xaviercoulmier.com

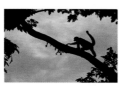

146
Louis de Montfort (UK)
jdemontfort@btinternet.com

40
Gertjan de Zoete (The Netherlands)
info@extremadura-spanje.com
www.extremadura-spanje.com

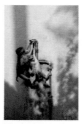

55
Greg du Toit (South Africa)
dutoitsinbundu@gmail.com
www.gregdutoit.com

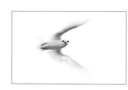

82
Carsten Egevang (Denmark)
arcpic@dbmail.dk
www.arc-pic.com

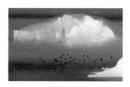

78
Lorenz Andreas Fischer
(Switzerland)
lafischer@allvisions.ch
www.allvisions.ch

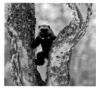

59
Andrew Forsyth (UK)
andrewforsyth@me.com
www.thewildlifephotographer.co.uk

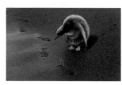

121
Robert Friel (UK)
rwfriel@googlemail.com
www.robfriel.com

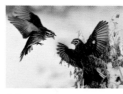

53
Daisy Gilardini (Switzerland)
dgilardini@bluewin.ch
www.daisygilardini.com

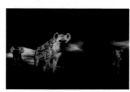

130
Fergus Gill (UK)
fergusgill@hotmail.co.uk
www.scottishnaturephotography.com

76
Sergey Gorshkov (Russia)
gsvl@mail.ru
www.gorshkov-photo.com
Agent
www.mindenpictures.com

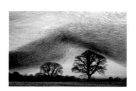

50
Danny Green (UK)
danny@dannygreenphotography.com
www.dannygreenphotography.com
Agents
www.rspb-images.com
www.nhpa.co.uk

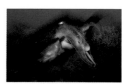

106
Christopher Guglielmo (USA)
aquaexposure@yahoo.com
www.aquaexposure.com

71
Jérôme Guillaumot (France)
jerome.guillaumot@wanadoo.fr
www.jerome-guillaumot.com

156

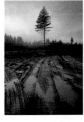

52
David Hackel and
Michel Poinsignon (France)
mich.poinsignon@wanadoo.fr
www.michelpoinsignon.com
Agents
www.biosphoto.com
naturepl.com

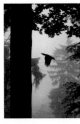

116
Thomas Haney (USA)
thoshaney@yahoo.com
www.thaney.com

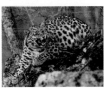

126
Andrew Harrington (UK)
harry@harringtonphotography.com
www.harringtonphotography.com

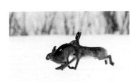

34
Janne Heimonen (Finland)
janne.heimonen@gmail.com
www.janneheimonen.net

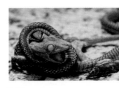

28
Morten Hilmer (Denmark)
mail@mortenhilmer.dk
www.mortenhilmer.dk

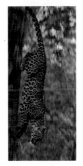

26
Ajit K. Huilgol (India)
ajithuilgol@gmail.com
www.wildandsavage.com

94
Cedric Jacquet (Belgium)
Info2009@cedricjacquet.com
www.cedricjacquet.com
Agent
www.flpa-images.co.uk

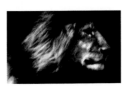

54
Britta Jaschinski (Germany)
info@brittaphotography.com
www.brittaphotography.com

144
Miles Kenzo Kooren
(The Netherlands)
kooren5@xs4all.nl

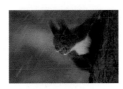

135
Jacek Kwiatkowski (Poland)
apjk@neostrada.pl
www.jacekkwiatkowski.pl

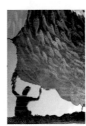

119
Frédéric Larrey (France)
flarrey@regard-du-vivant.fr
www.regard-du-vivant.fr

32
Eric Lefranc (France)
eclefranc@wanadoo.fr
www.ericlefranc.com
Agents
www.biosphoto.com
www.fotonatura.com
www.osf.co.uk

85
Magnus Lindbom (Sweden)
info@magnuslindbom.com
www.magnuslindbom.com

96, 102
Michel Loup (France)
loupmichel@wanadoo.fr
www.michelloup.com

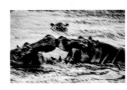

92
Henrik Lund (Finland)
henrik.lund@lundfoto.com
www.lundfoto.com

68
Joe McDonald (USA)
info@hoothollow.com
www.hoothollow.com

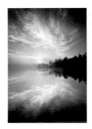

16
Esa Malkonen (Finland)
esa.malkonen@luukku.com
www.malkonen.fi

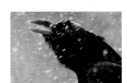

56
Sheri Mandel (USA)
sheri@sherimandel.com
www.sherimandel.com

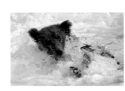

77
Jarmo Manninen (Finland)
jarmo@luontokuvat.net
www.luontokuvat.net

Index of photographers

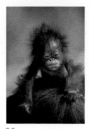

80
Brian W. Matthews (UK)
brian@bwmphoto.com
www.bwmphoto.com

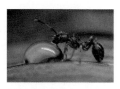

44
András Mészáros (Hungary)
andras@smlogistic.hu
www.meszarosandras.com

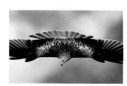

69
Javi Montes (Spain)
javimon@telefonica.net
www.javimontes.com

124
Juan Carlos Muñoz (Spain)
jcmunoz@artenatural.com
www.artenatural.com
Agent
naturepl.com

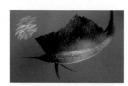

134
Aleksander Myklebust (Norway)
aleksander-myklebust@hotmail.com
www.almyfoto.com

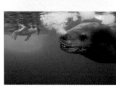

20
Ewald Neffe (Austria)
ewald.neffe@aon.at
www.ewaldneffe.com

75
Andy Nguyen (Vietnam/USA)
songlove@ndshow.com
www.ndshow.com

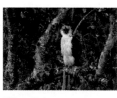

128
Klaus Nigge (Germany)
klaus.nigge@t-online.de
www.nigge.com

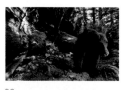

98
Michael Nichols (USA)
stock@ngs.org
www.michaelnicknichols.com
Agent
www.nationalgeographicstock.com

142
Hans Nuijt (The Netherlands)
hansnuyt@gmail.com

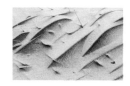

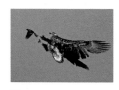

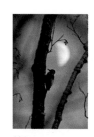

48, 108, 110
Paul Nicklen (Canada)
nicklen@northwestel.net
www.paulnicklen.com
Agent
www.nationalgeographicstock.com

62
Mariusz Oszustowicz (Poland)
moszustowicz@poczta.onet.pl
www.mariuszoszustowicz.pl

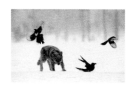

36
Rob Palmer (USA)
rob@falconphotos.com
www.falconphotos.com

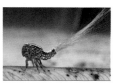

132
Niko Pekonen (Finland)
niko.pekonen@gmail.com
www.npekonen.com

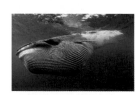

114
Doug Perrine (USA)
perrine@hawaii.rr.com
www.dougperrine.com
Agent
info@seapics.com
www.seapics.com

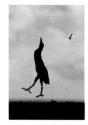

39
Thomas P. Peschak (South Africa)
tpeschak@iafrica.com
www.thomaspeschak.com
Agent
www.saveourseas.com

30
Seppo Pöllänen (Finland)
seppo.pollanen@digiexpress.fi
www.vespertinus.fi

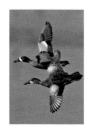

46
Alexandr Pospech (Czech Republic)
a_pospech@yahoo.com
www.photographypospech.com

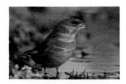

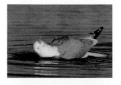

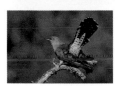

148, 152, 154
Ilkka Räsänen (Finland)
Ilkkao.rasanen@pp.inet.fi

61
Ana Retamero (Spain)
retamero.olmos@gmail.com
www.anaretamero.com

14, 64
José Luis Rodríguez (Spain)
joseluis@joseluisrodriguez-
fotografo.com
www.joseluisrodriguez-fotografo.com

141, 145
Stephan Rolfes (Germany)
stephan_rolfes@hotmail.de

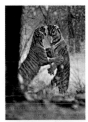

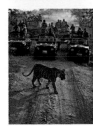

33, 120
Andy Rouse (UK)
Andy.rouse@btconnect.com
www.andyrouse.co.uk

138
Sam Rowley (UK)
samrowley@hotmail.co.uk
www.sam-rowley.com

104
Alexander Safonov (Russia)
Pats0n@yahoo.com
http://pats0n.livejournal.com

42
Paul Sansome (UK)
info@pspimages.com
www.paulsansome.com

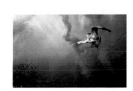

24, 70, 107
Kevin Schafer (USA)
Kevin@kevinschafer.com
www.kevinschafer.com

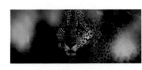

122
Tom Schandy (Norway)
tschandy@online.no
www.tomschandy.no

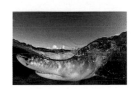

113
Dániel Selmeczi (Hungary)
selmeczidaniel@t-online.hu
www.selmeczidaniel.com

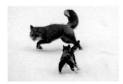

58
Igor Shpilenok (Russia)
shpilenok@mail.ru
www.shpilenok.com
Agent
naturepl.com

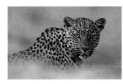

72
Lee Slabber (South Africa)
slabber@rocketmail.com
www.leeslabber.com

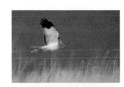

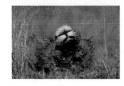

38, 66
Marc Slootmaekers (Belgium)
marc.slootmaekers1@telenet.be

137
Daniel Szabo (Hungary)
daniel07@citromail.hu

81
Klaus Tamm (Germany)
btamm1@aol.com
www.tamm-photography.com

88
Urmas Tartes (Estonia)
Urmas.Tartes@hot.ee
www.hot.ee/utartes

60
Serge Tollari (France)
sergetollari@free.fr
www.sergetollari.com

100
Stefano Unterthiner (Italy)
info@stefanounterthiner.com
www.stefanounterthiner.com
Agent
agent@stefanounterthiner.com

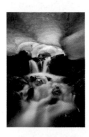

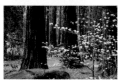

63, 84, 90
Floris van Breugel (USA)
florisvb@gmail.com
www.ArtInNaturePhotography.com

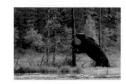

47
Chris van Rooyen (South Africa)
chris@wildlifephotography.co.za
www.wildlifephotography.co.za

74
Jan Vermeer (The Netherlands)
Janvermeer.foto@planet.nl
www.janvermeer.nl
Agent
www.fotonatura.com

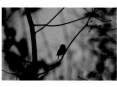

150
Noam-Pierre Werlé (France)
ruth.alimi@orange.fr

153
Mimmi Widstrand (Sweden)
photo@staffanwidstrand.se

22
Lawrence Alex Wu (Canada)
AlexW@AGuaPictures.com
www.AGuaPictures.com